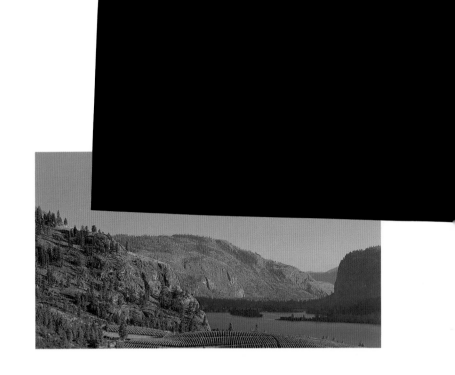

OKANAGAN

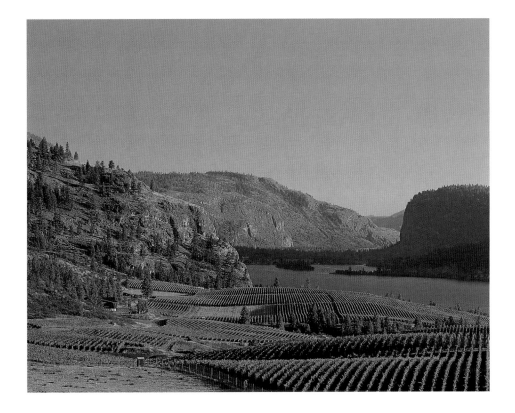

WHITECAP BOOKS

VANCOUVER / TORONTO

Cover and book design by Steve Penner
Text by Tanya Lloyd
Edited by Elaine Jones
Proofread by Lisa Collins

Printed and bound in Canada by Friesens, Altona, Manitoba.

Canadian Cataloguing in Publication Data
Lloyd, Tanya, 1973-
 Okanagan

 ISBN 1-55110-868-2

 1. Okanagan Valley (B.C.) —— Pictorial works. I. Title.
FC3845.O4L66 1999 971.1'5 C98-911023-0
F1089.O5L66 1999

The publisher acknowledges the support of the Canada Council and the
Cultural Services Branch of the Government of British Columbia in making
this publication possible. We acknowledge the financial support of the
Government of Canada through the Book Publishing Industry Development
Program for our publishing activities.

**For more information on this series and other Whitecap
Books titles, visit our web site at www.whitecap.ca.**

Sparkling lakes set sharply against desert-like hills: since the 1800s, this land of blue and gold has captivated visitors. In fact, many have been so enthralled by the Okanagan's beauty, they've made the region their home. Kelowna, Penticton, Vernon, and the many small towns that dot the valley are steadily growing, as more and more people fall in love with the Okanagan's long summers, relaxed atmosphere, and recreational opportunities.

Water-skiing on Skaha Lake, golfing at Predator Ridge, skiing Big White, or snowmobiling the surrounding mountains — there is something for everyone here. Osoyoos booms each summer, as thousands of visitors flock to the shores of Canada's warmest freshwater lake. In Penticton, crowds gather to cheer on the leaders in the Ironman Canada Triathlon. Just a few miles away, cyclists escape into the past along the trails and trestles of the Kettle Valley Railway. And no tour of the Okanagan is complete without a visit to one of hundreds of fruit stands.

The region's fruit-growing fame blossomed in the late 19th century, when settlers such as Father Pandosy and Thomas Ellis planted the first orchards. The fruit trees of Lord and Lady Aberdeen, among others, made the Okanagan the biggest fruit-producing region in the British Empire. Even today, the valley produces more fruit than anywhere else in Canada — more than 6.5 million kilograms (14 million pounds) of cherries alone.

In recent years, the reputation of the valley's wineries has begun to rival that of the orchards. Vintners are producing the highest quality grapes, winning international awards, and earning the Okanagan Valley a place on the international map. The popularity of winery tours brings even more visitors to the region — visitors who discover the Okanagan's unique blend of sun, sand, and sagebrush that residents have always treasured.

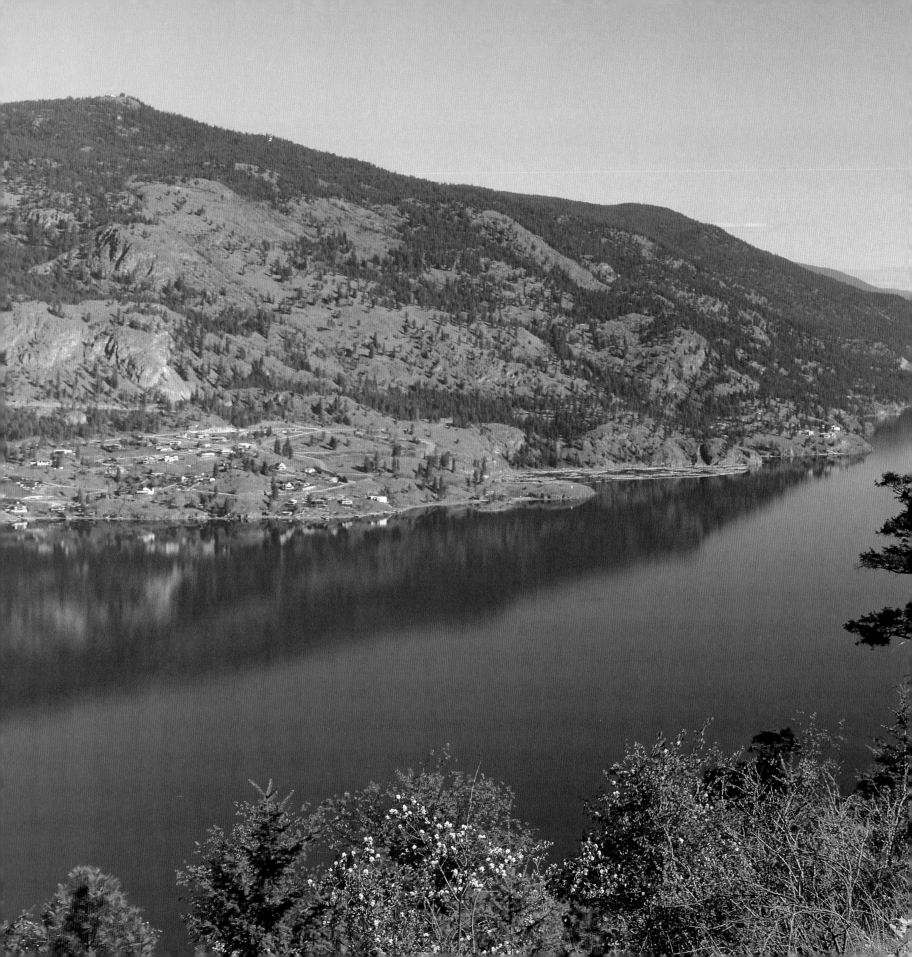

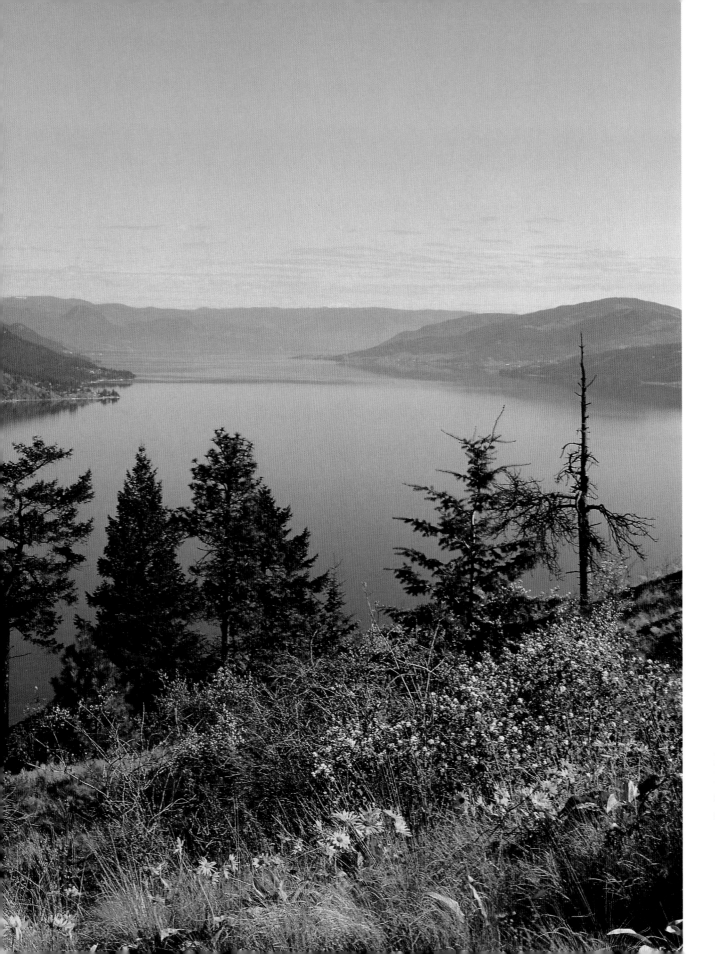

Nature trails on
Knox Mountain offer
stunning views over
Okanagan Lake.

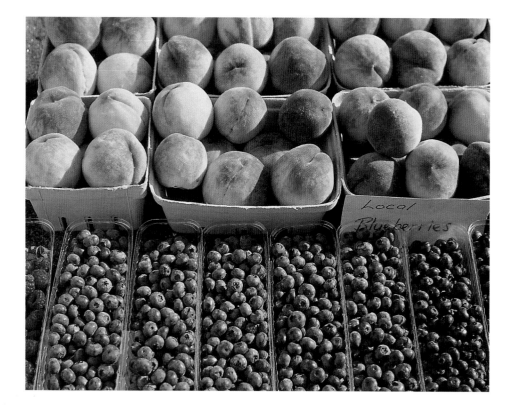

The Okanagan produces about 20 percent of Canada's peaches.
The mild climate of the southern valley is especially suited to these
soft fruits, and visitors will find a ready supply at any fruit stand.

Many British Columbian winemakers
have trained in Europe or California.
Adapting knowledge from around the
world to the Okanagan's unique climate
has continued to increase the quality
of the region's wines.

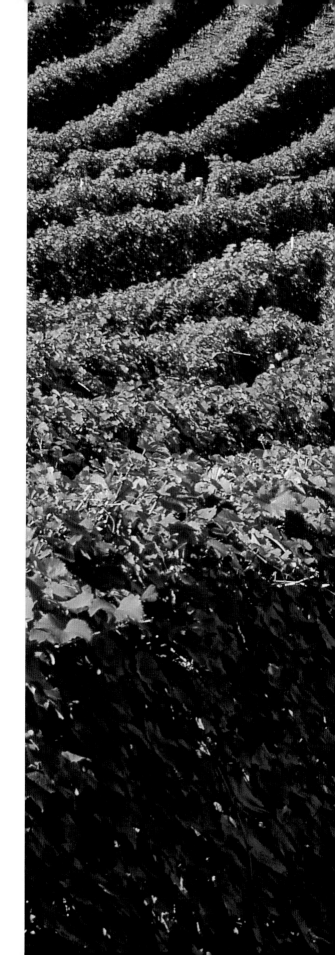

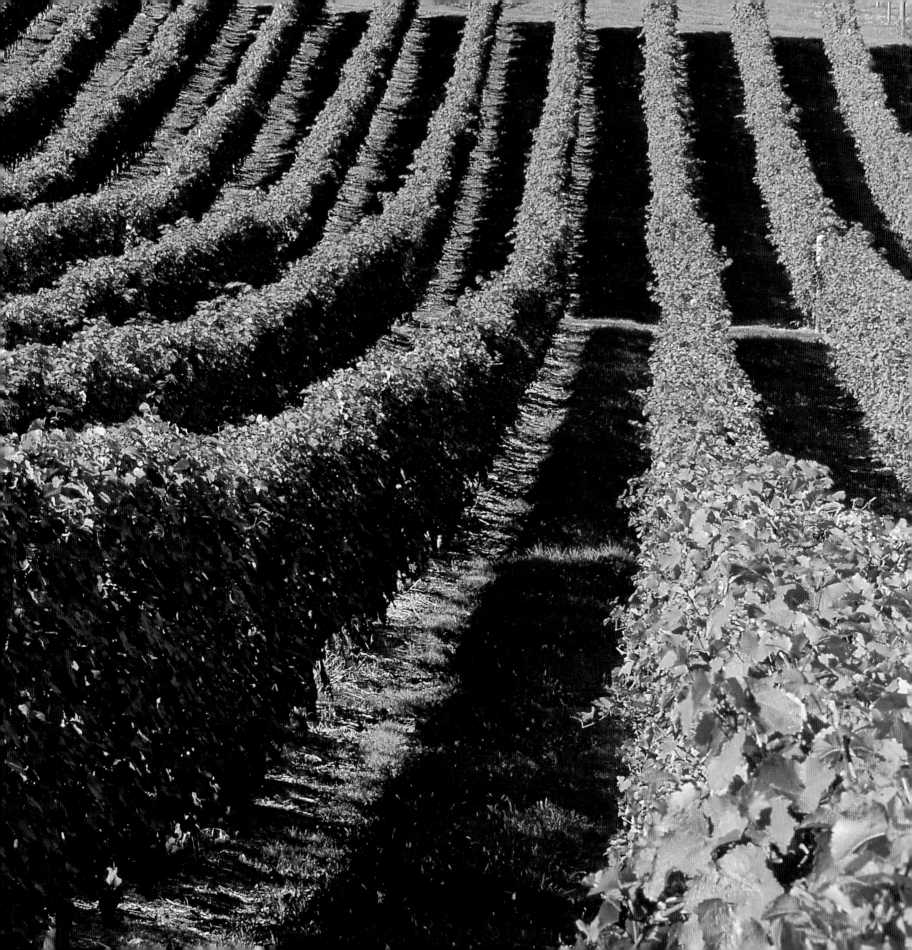

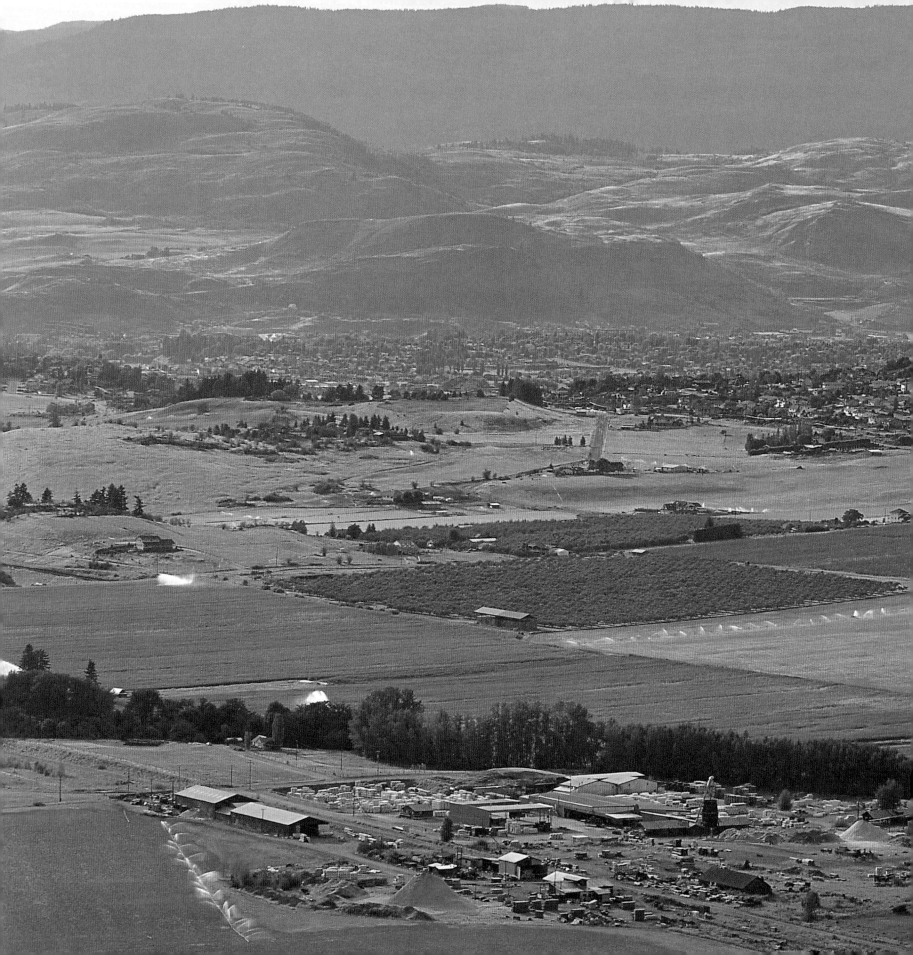

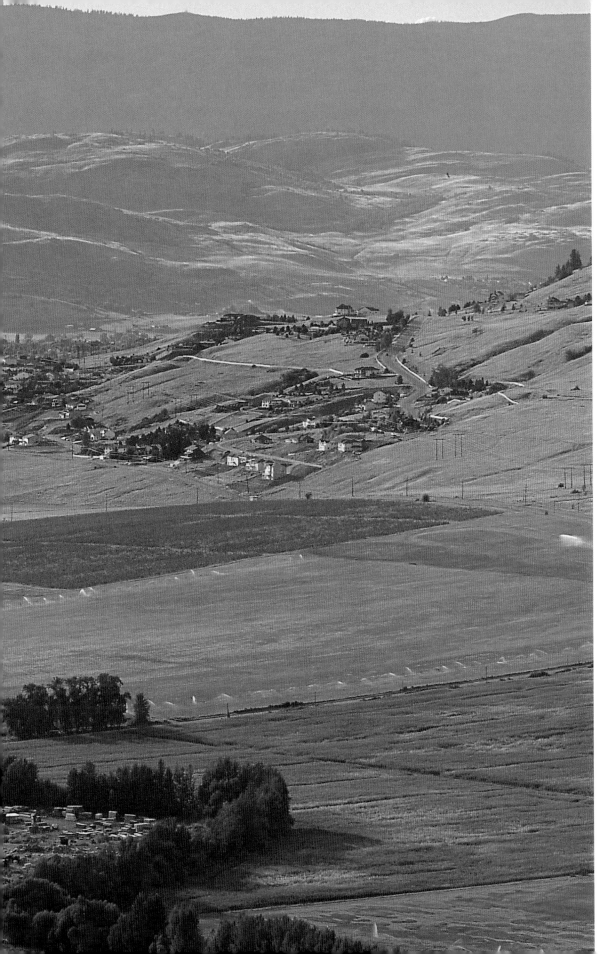

There are three major mills in the northern Okanagan: Riverside Forest Products, Tolko Industries, and Weyerhauser Canada. The area's forestry and silviculture industry employs more than 1000 people.

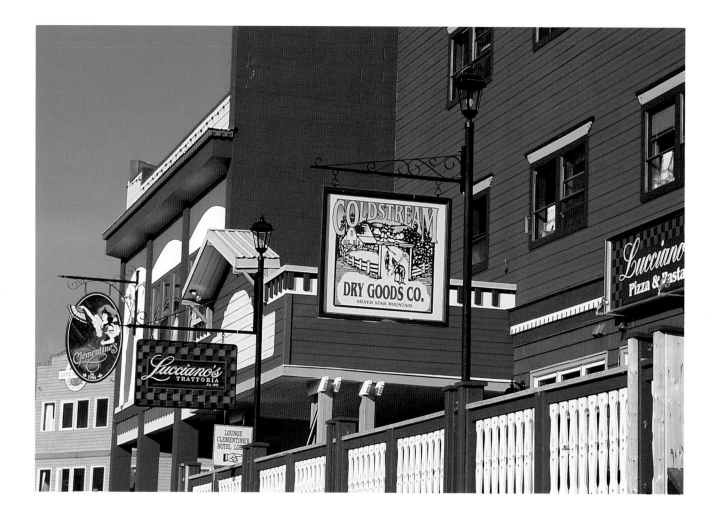

Twenty kilometres northeast of Vernon, Silver Star Resort offers 485 hectares (1200 acres) of skiable terrain. And with an average annual snowfall of five metres (16 feet), the mountain has powder to spare.

Irrigation pipes are the lifeblood of the valley's agriculture. In many communities, such as Peachland, Summerland, and Penticton, the land was irrigated before it was settled.

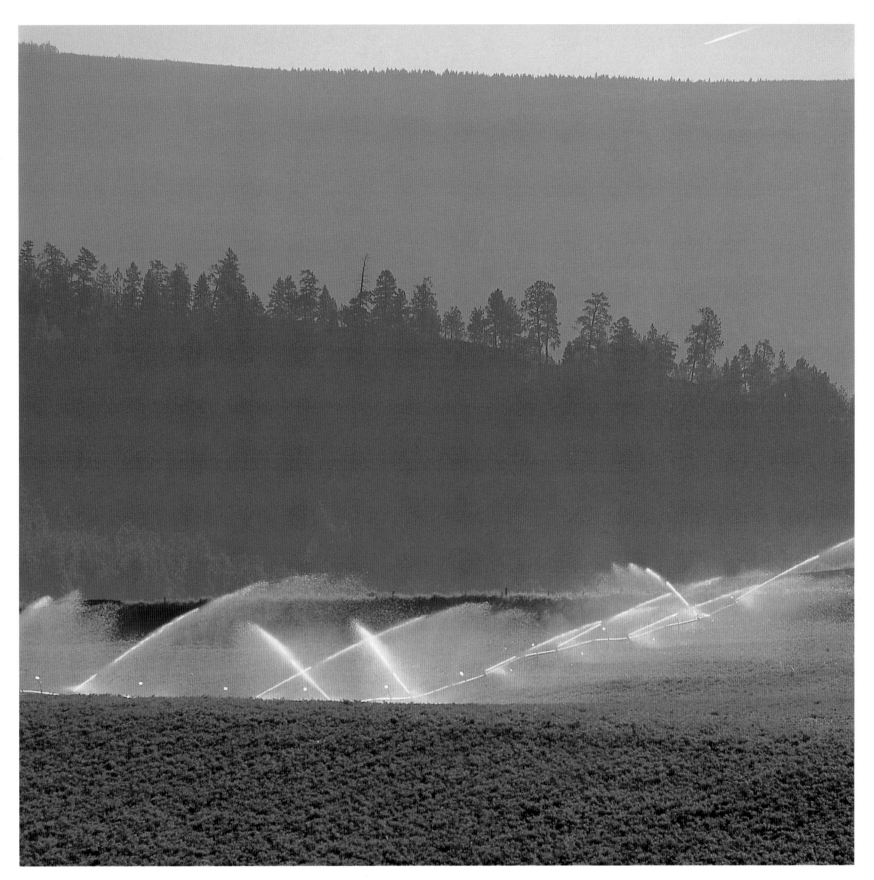

Vernon's library and museum offer information on the community's varied history. The Okanagan's oldest city, Vernon was incorporated in 1892.

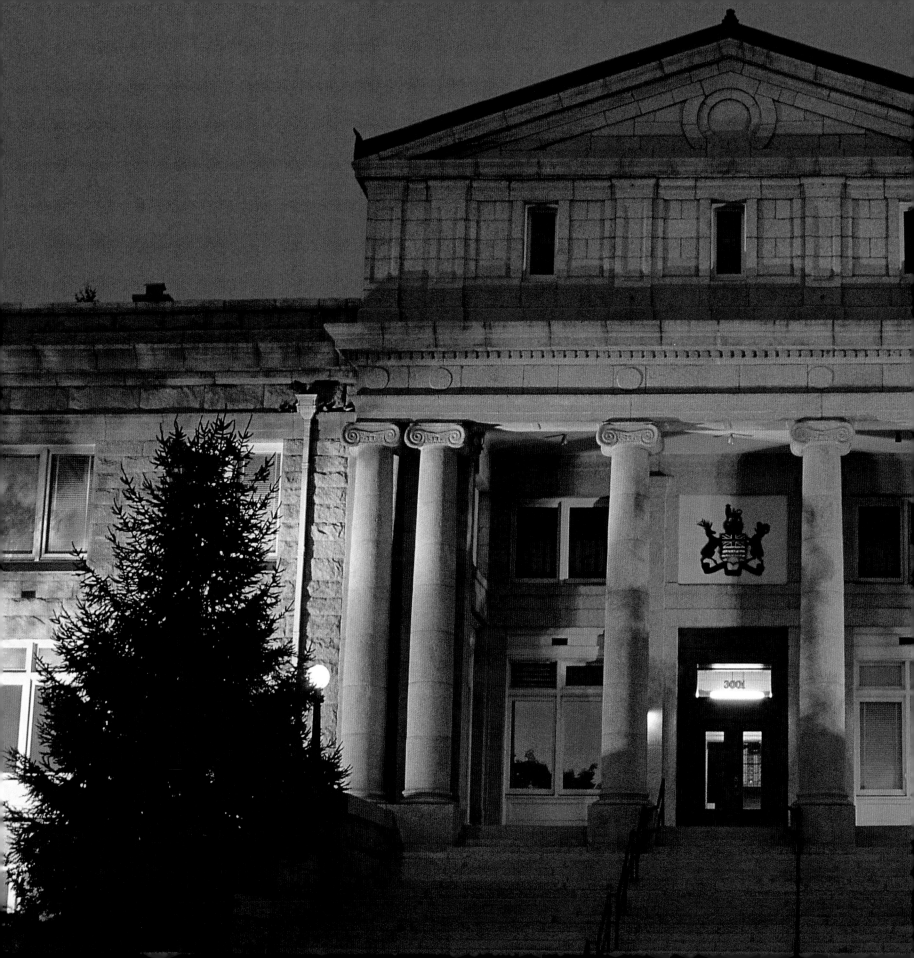

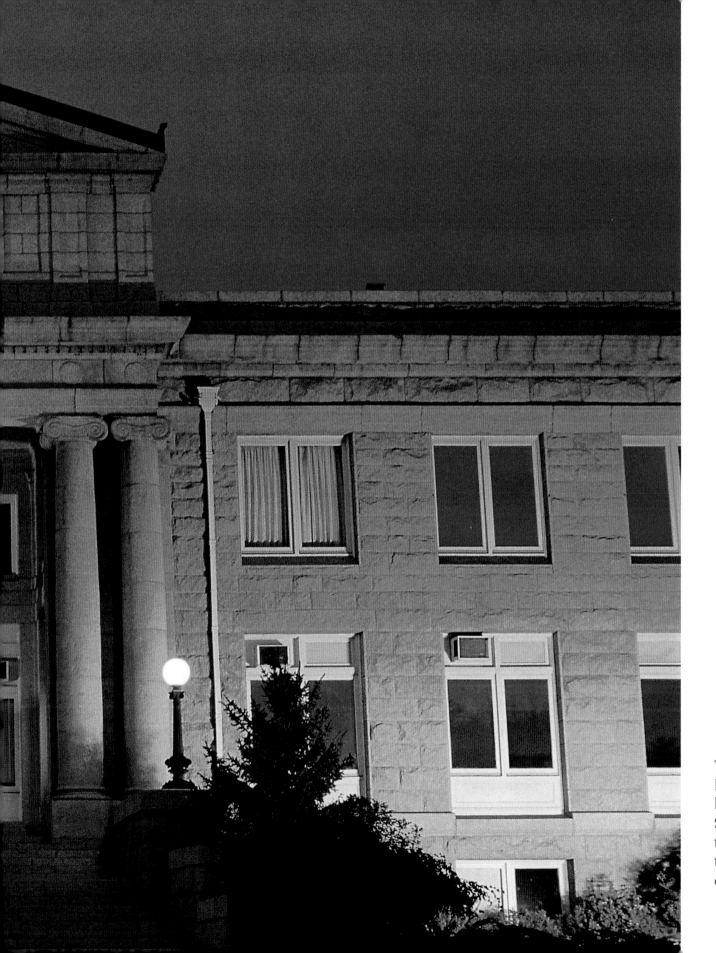

The Vernon Court House was built with local granite in 1914. Seven-tonne (eight-ton) blocks were transported by boat down the lake.

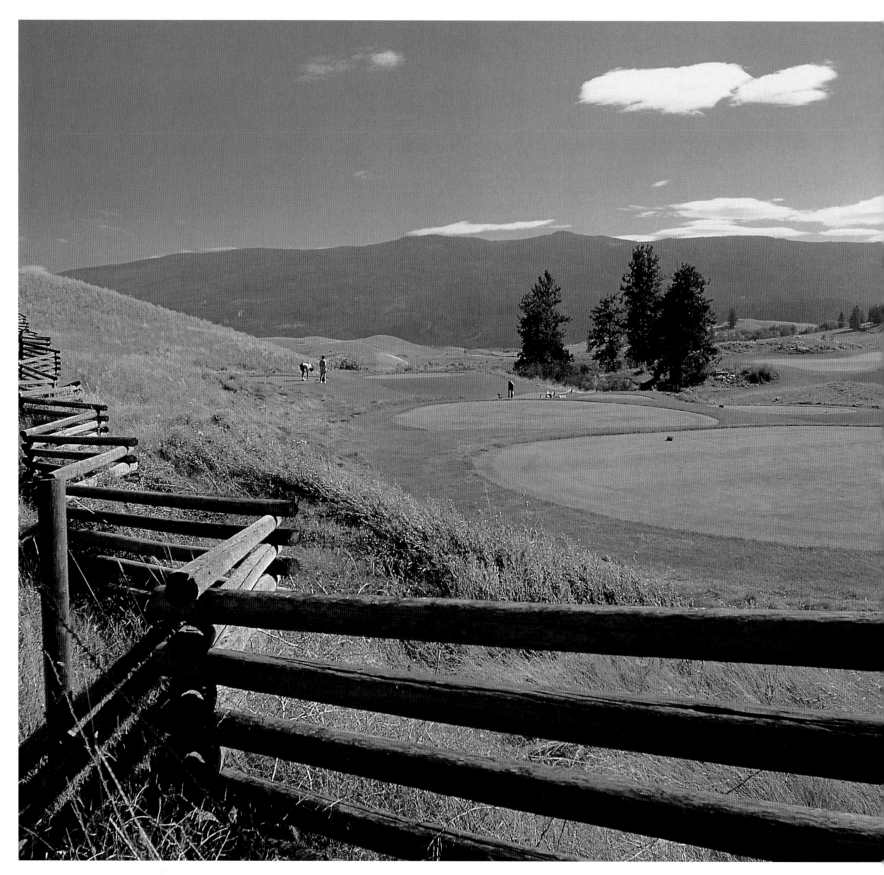

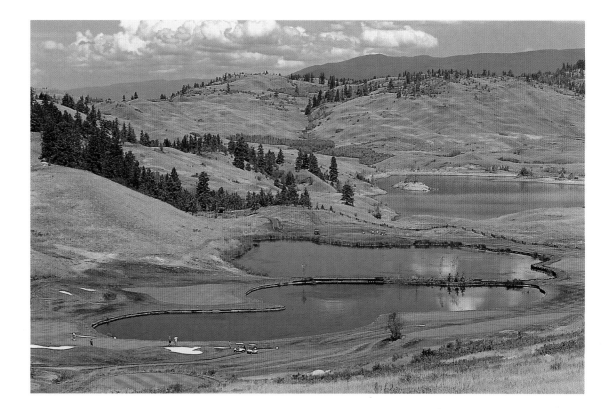

The flourishing greens at Predator Ridge contrast markedly with the arid hills that surround the course. Orchards and parks create similar scenes amidst the region's desert-like landscape.

Just south of Vernon, Predator Ridge Golf Resort combines breathtaking scenery with world-class golfing. The par 73 course has both traditional and open-link fairways, separated by different colours of grass.

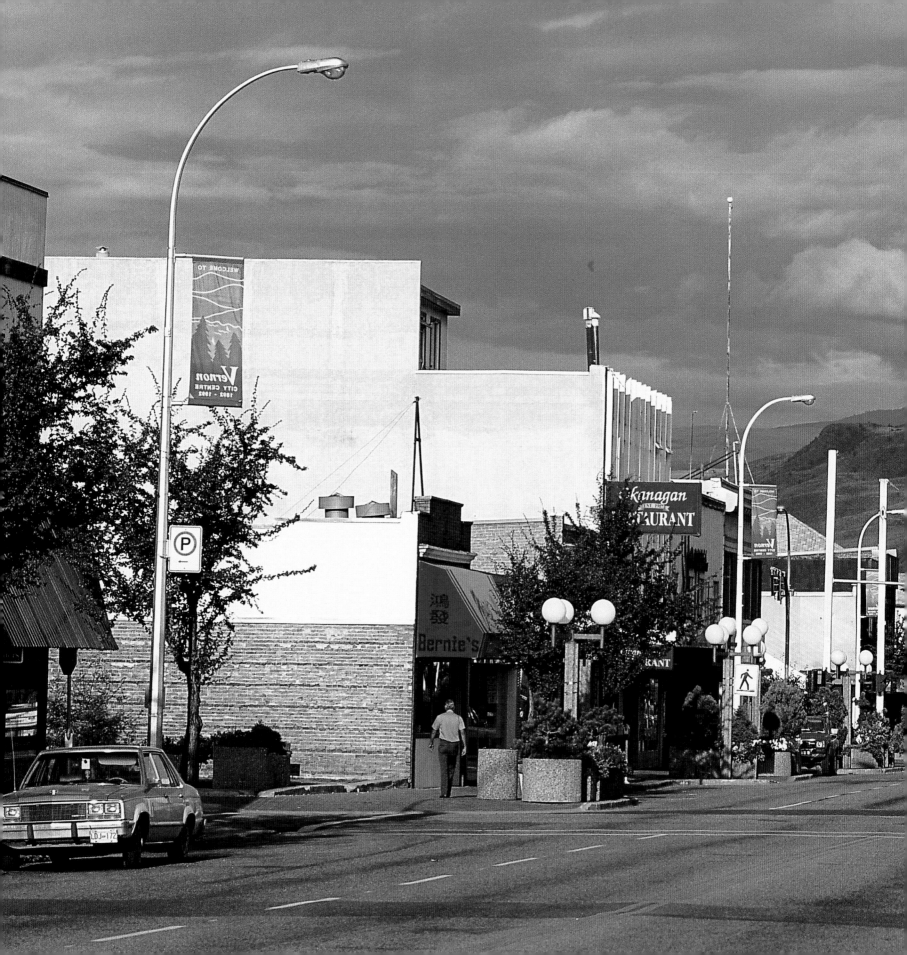

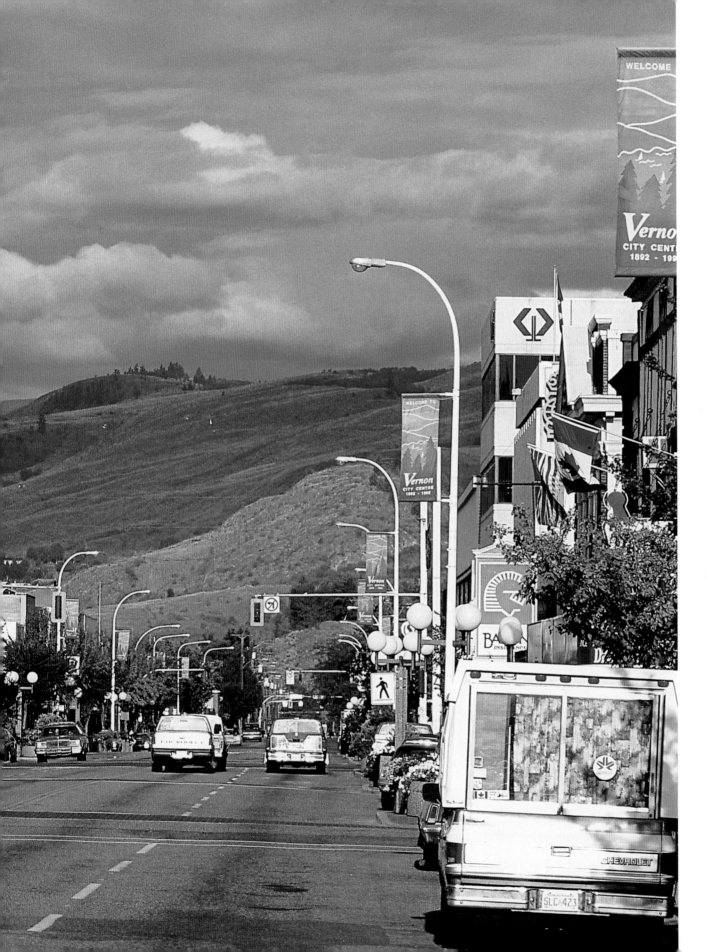

The Priest, Pleasant, Coldstream, and Mission valleys converge in Vernon. Orchards planted here by Lady and Lord Aberdeen once made the area the largest producer of fruit in the British Empire. Now, Vernon is one of the Okanagan's steadily growing cities.

21

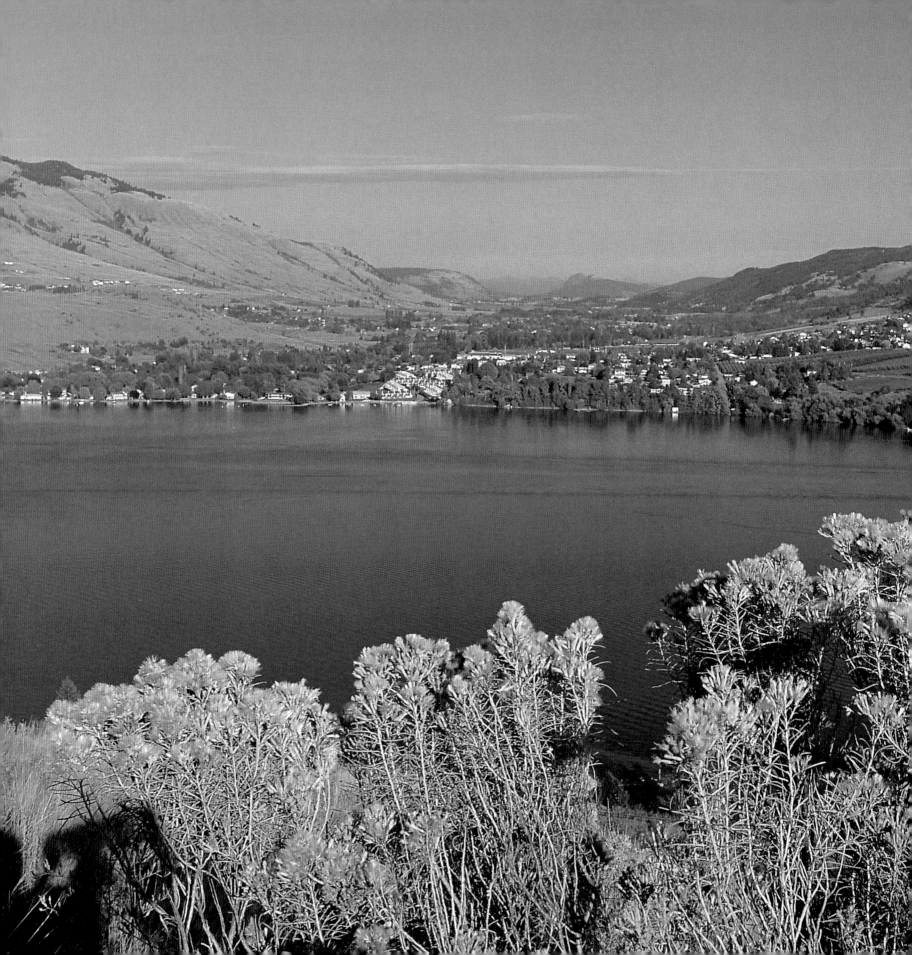

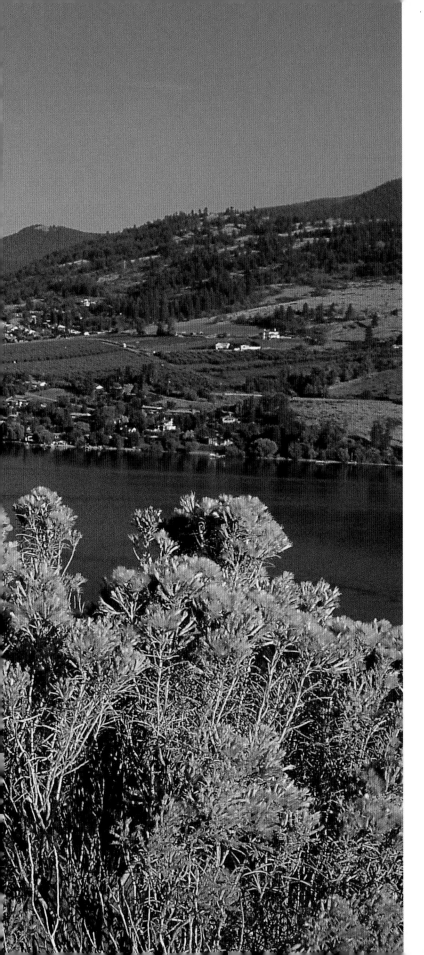

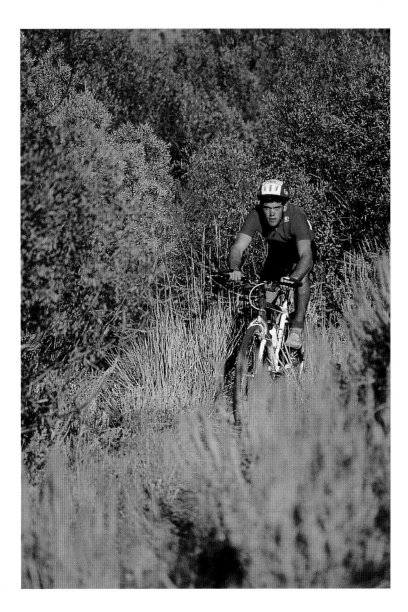

Mountain bikers can choose between an easy peddle along the Kettle Valley Railway, a hair-raising 40-kilometre (25-mile) downhill trail system from Silver Star Resort, or dozens of trails in between.

Sandy patches on the bottom of Kalamalka Lake create patterns of blue and green, earning it the nickname "lake of a thousand colours."

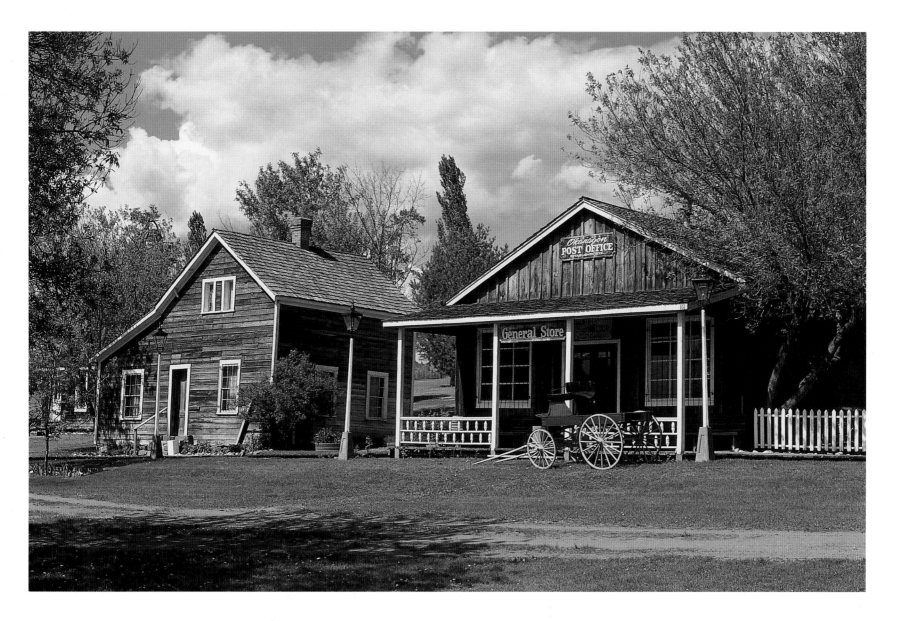

The store on the O'Keefe Ranch was the first in the district. The ranch also boasted its own post office, flour mill, and church.

Cornelius O'Keefe was a prospector and road-builder before joining Thomas Greenbow to drive cattle from Oregon to the Okanagan Valley. O'Keefe homesteaded 66 hectares (162 acres) in the late 1800s and built one of British Columbia's first cattle empires.

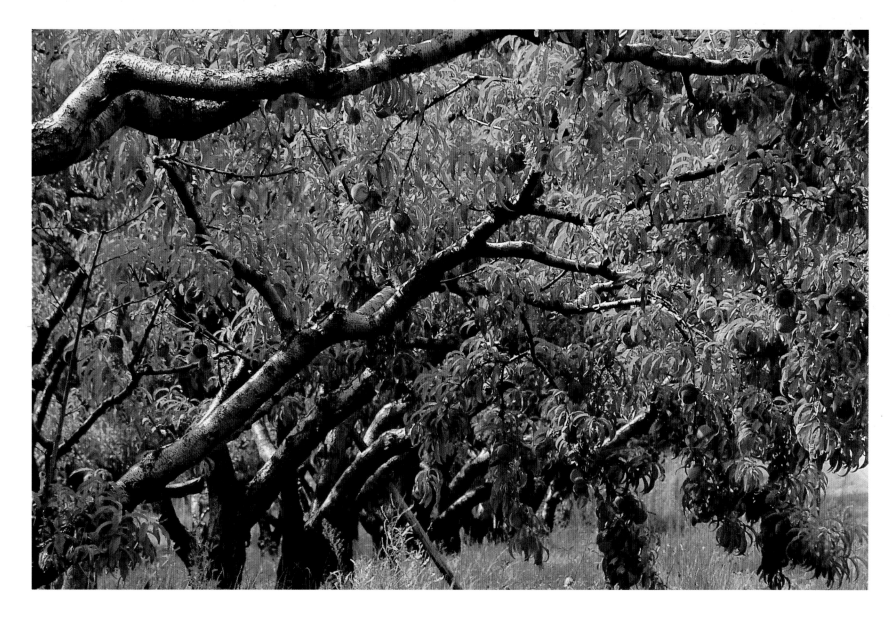

At the turn of the century, there were already
more than a million fruit trees in the valley.

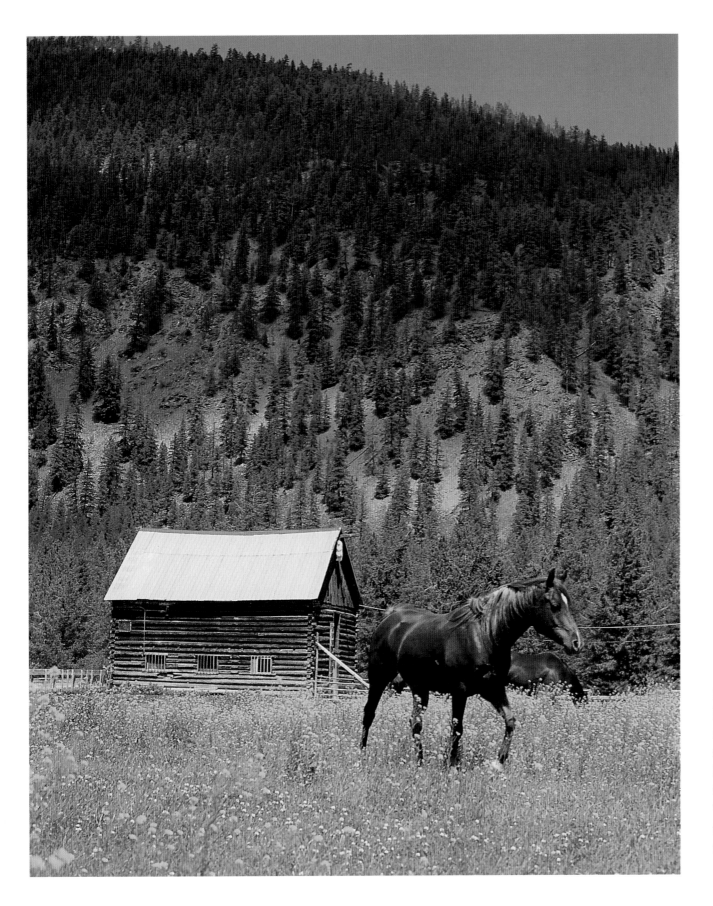

Farming and ranching have always played a major role in the area surrounding Vernon. In fact, it was settlers Charles and Forbes Vernon who began the first ranch in the 1860s.

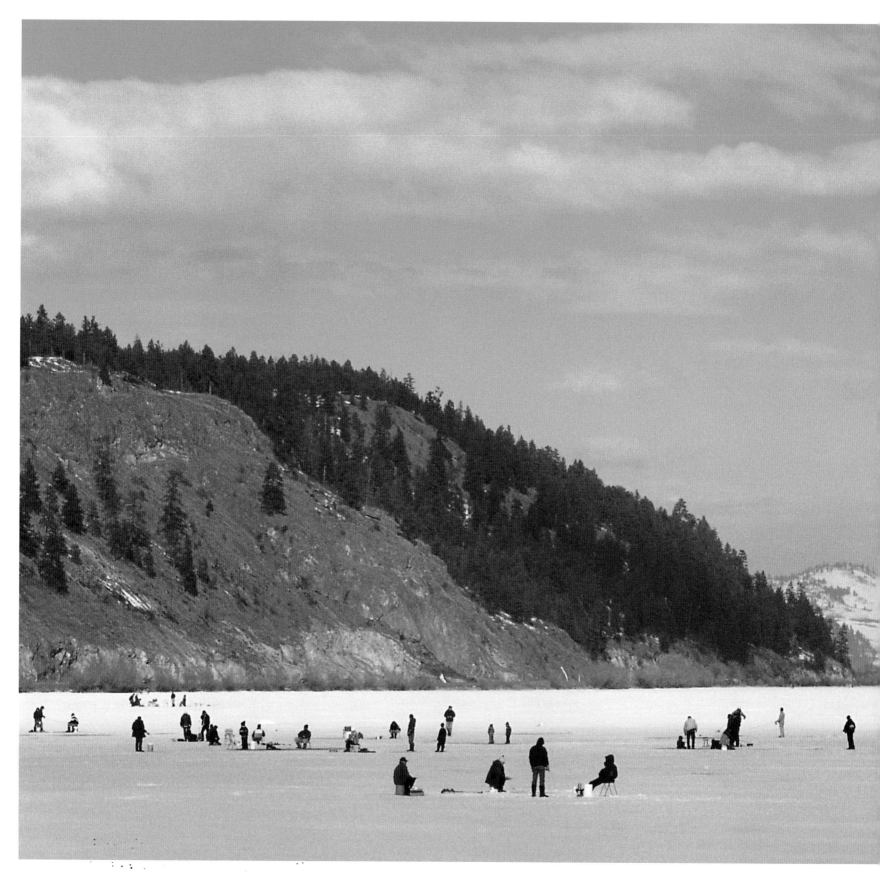

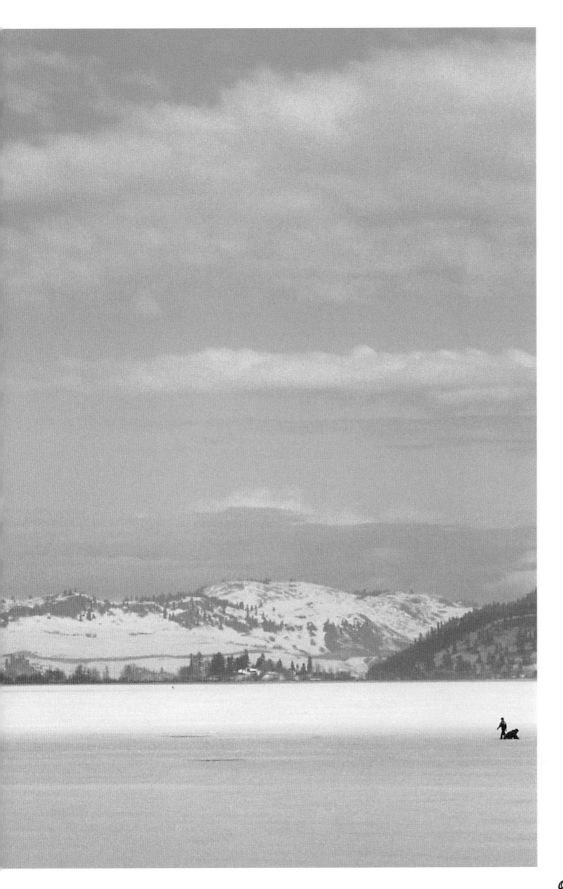

In any season, Wood Lake is a prime fishing spot. Along with Swan Lake, north of Vernon, this is a favourite lake for ice fishing. Many of the Okanagan's fishing resorts, open year-round, encourage visitors to take part in the chilly fun.

HIGHWAY 97 RUNS ALONG THE WEST SIDE OF WOOD LAKE. I WORK HERE QUITE A LOT

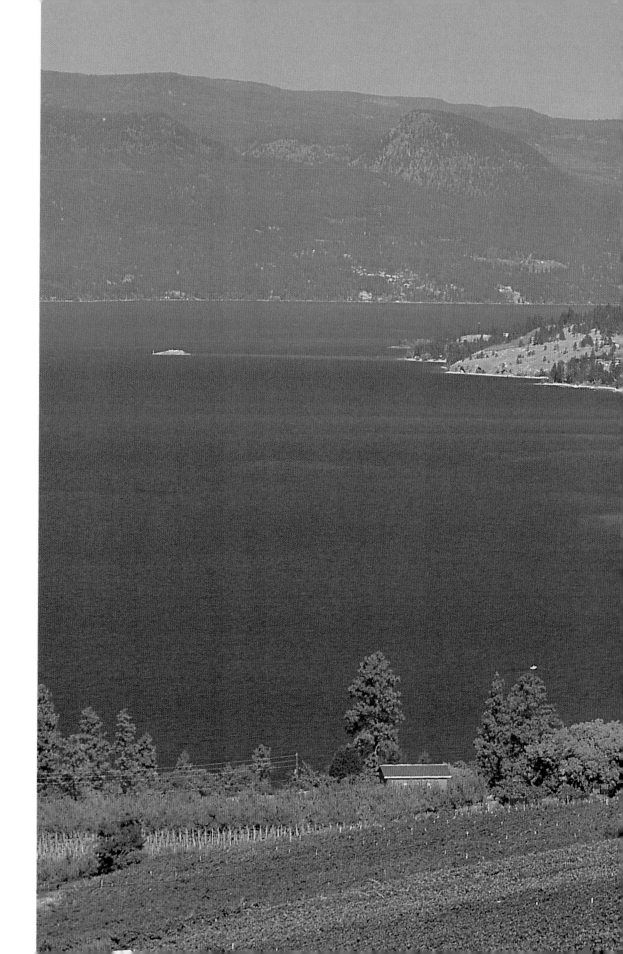

Typical of the Okanagan's scenery, this area near Winfield is a juxtaposition of vivid blue water, green fields, and mountain slopes.

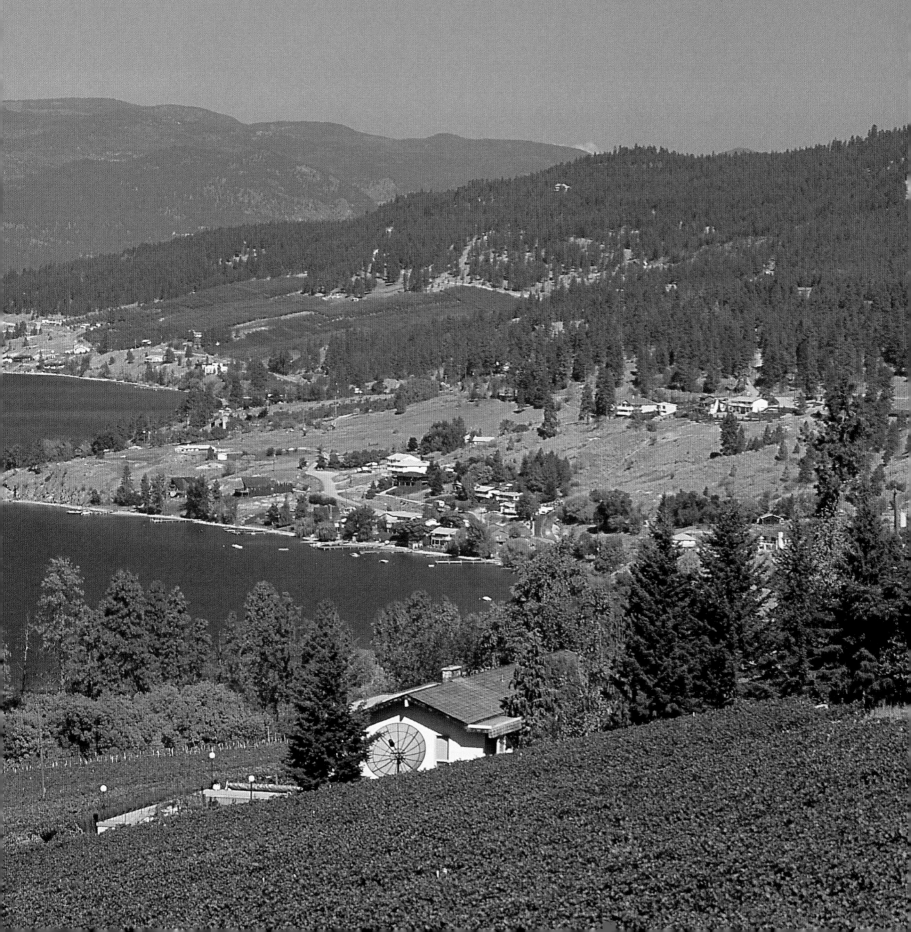

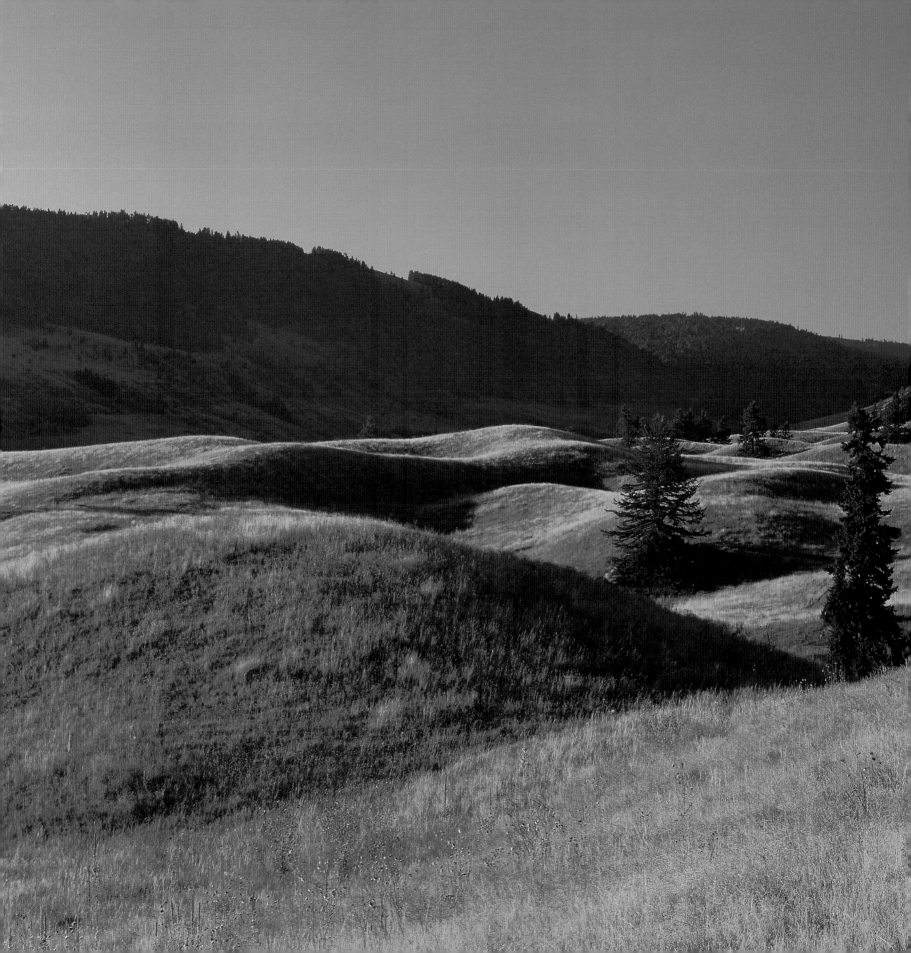

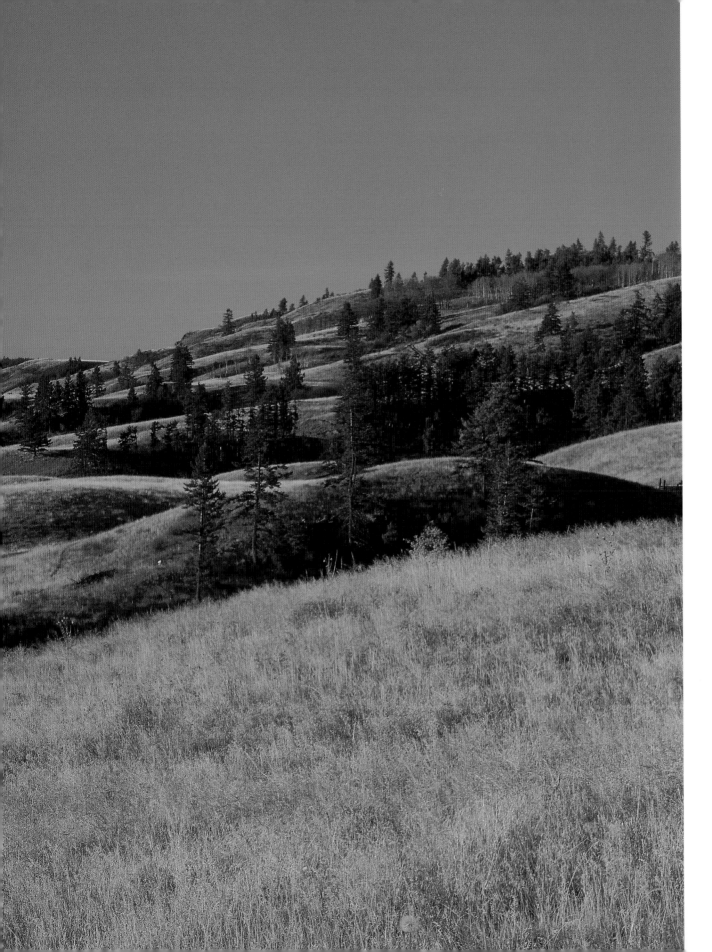

Rolling mountains
characterize the
Okanagan Highlands,
east of the valley.

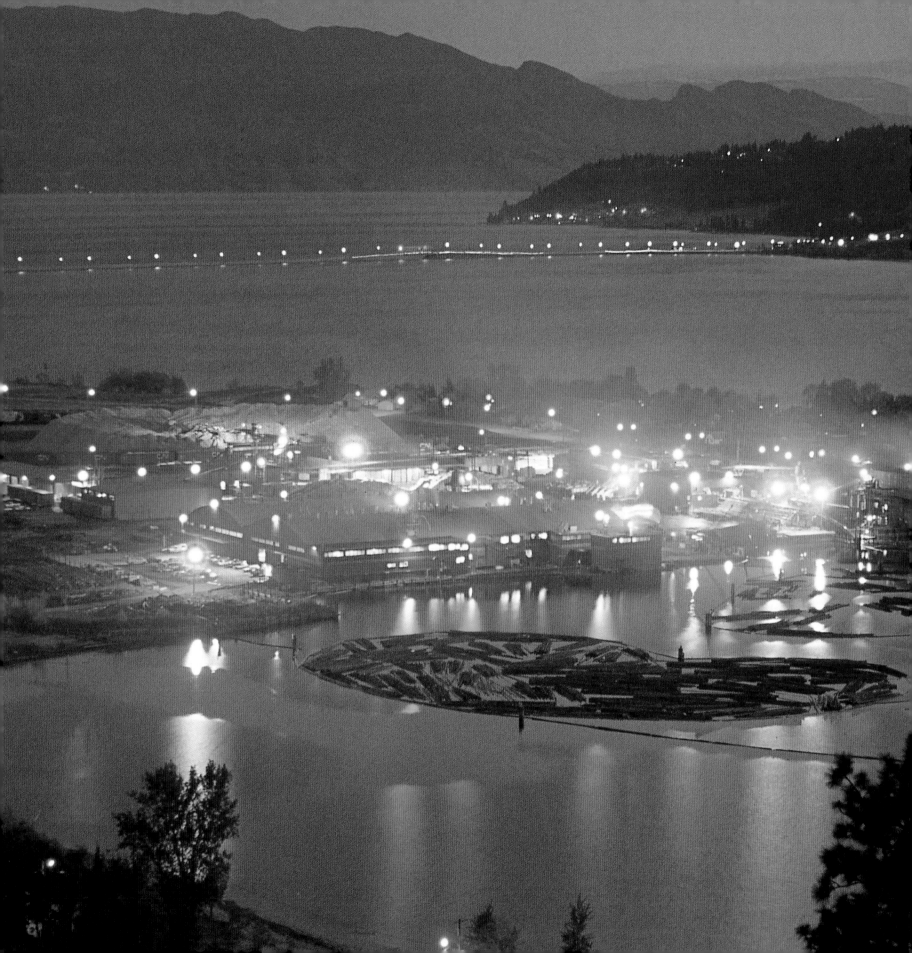

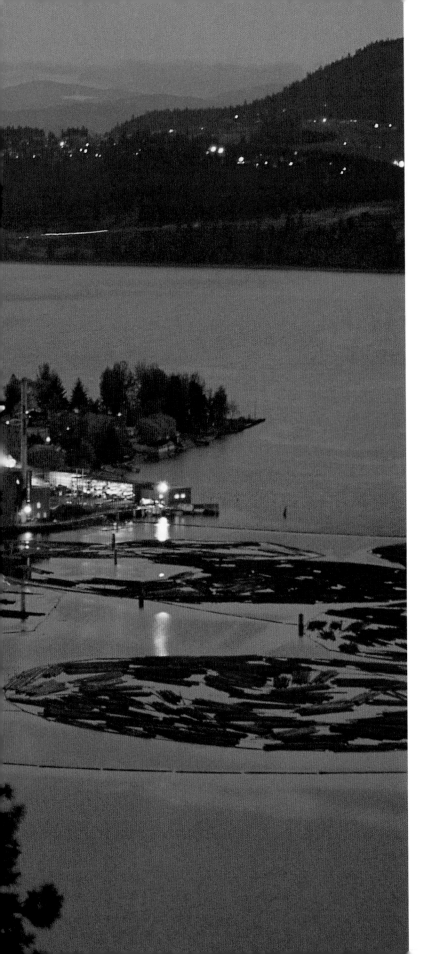

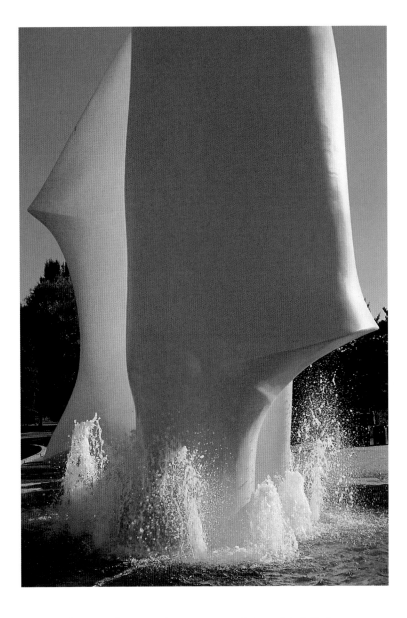

The Sails, a sculpture by Don Reid, is a highlight of Kelowna's waterfront.

Kelowna's 1100-metre (3610-foot) floating bridge sits on giant concrete pontoons. The bridge was opened by Princess Margaret in 1958.

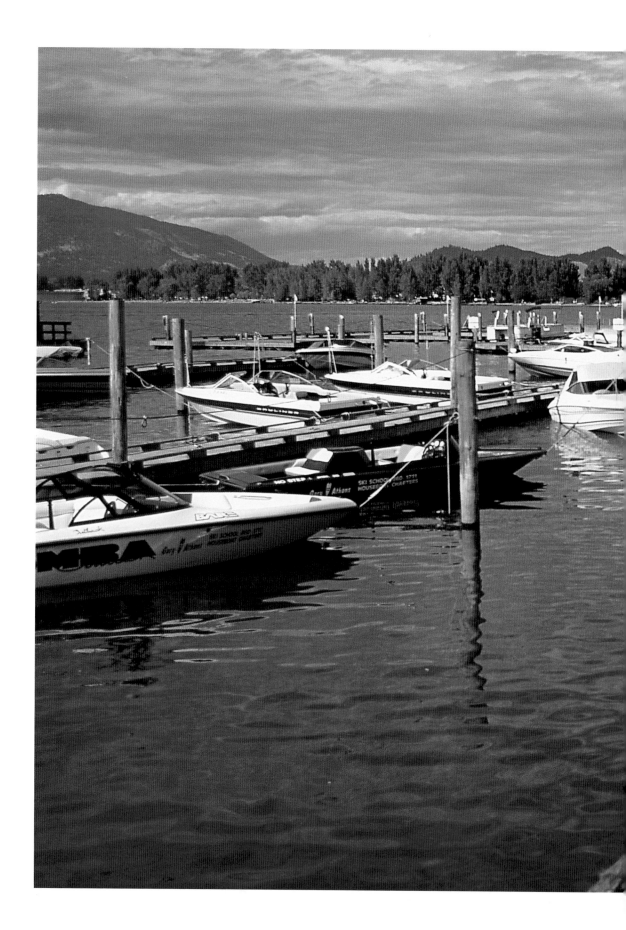

The Kelowna area is home to more than 120,000 people, drawn by recreation activities from sunbathing to skiing, business opportunities, and retirement. About 25 percent of the population is over 65.

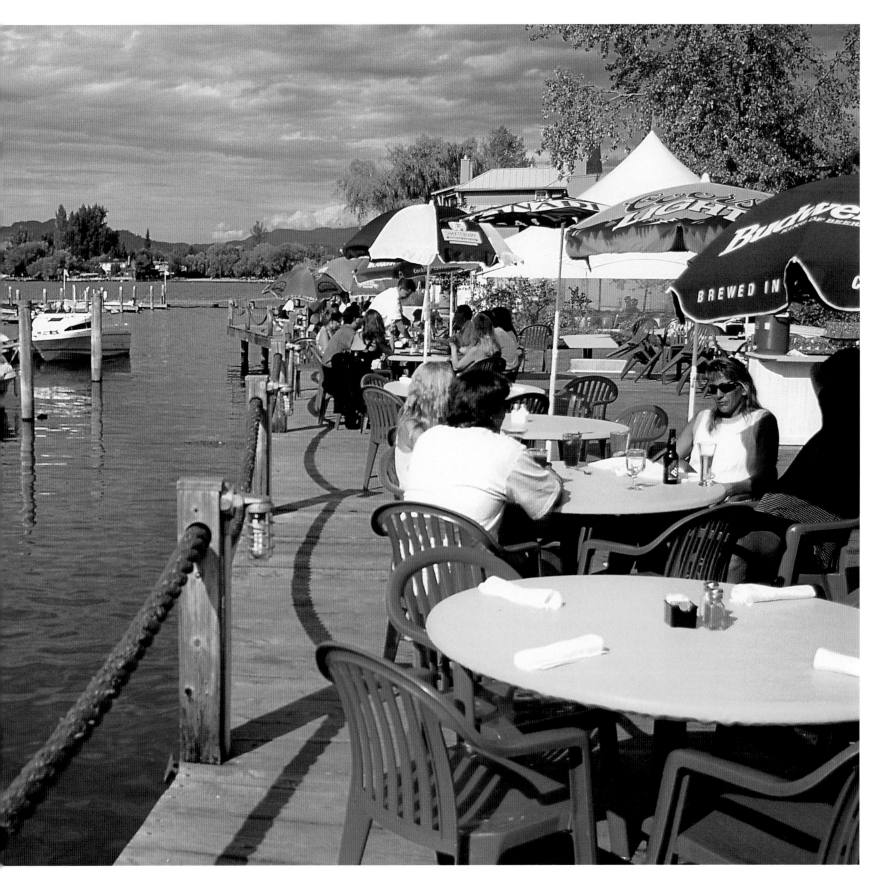

The Ogopogo is a legendary lake monster, said to inhabit the waters of Okanagan Lake. Tales of the serpent began before the arrival of European settlers, when First Nations people made offerings to the monster N'ha-a-itk.

About 120 kilometres (75 miles) long and 3.5 kilometres (2 miles) wide, the lake offers plenty of prime Ogopogo habitat.

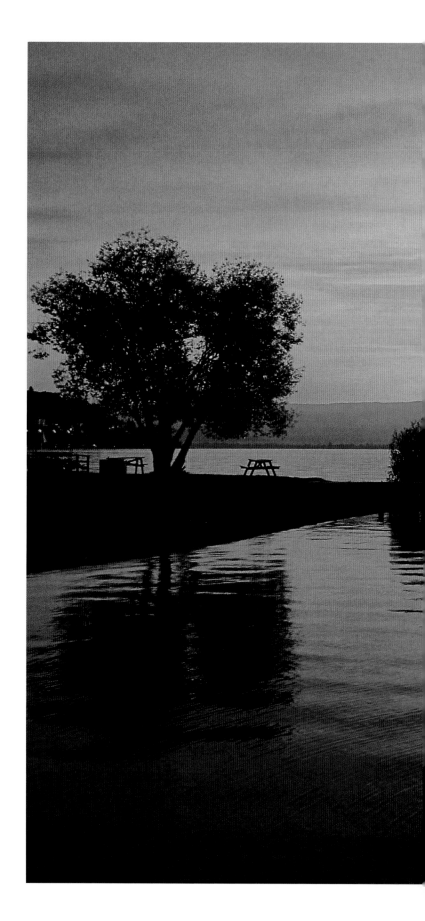

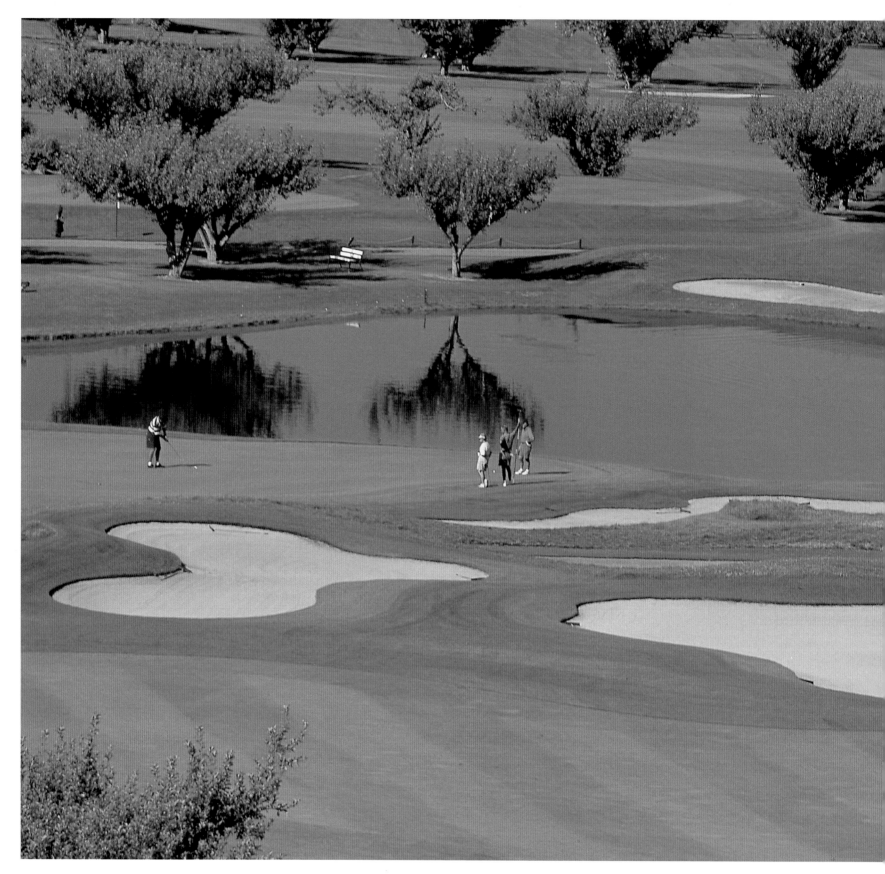

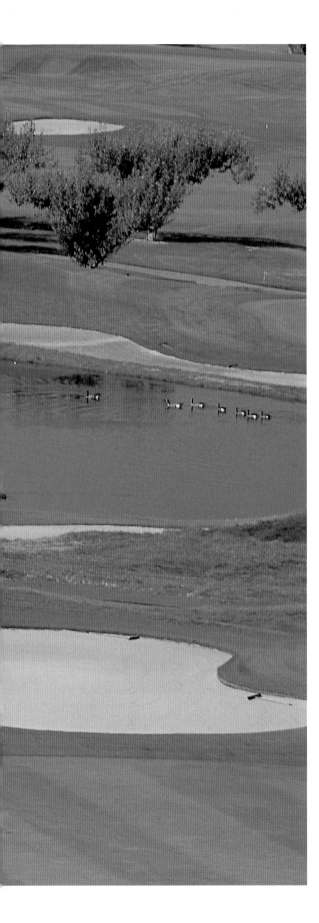

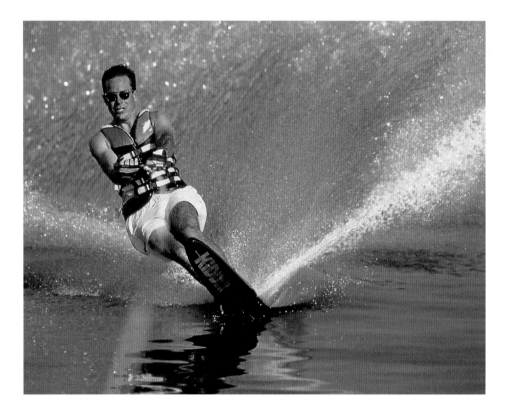

Water-skiers are a common sight on Okanagan Lake. In fact, many competitive water-skiers train on the warm and calm waters of the region's lakes.

Harvest Golf Course is just one of more than 40 courses in the Okanagan. A playing season that stretches from March to November helps to draw golfers to the region.

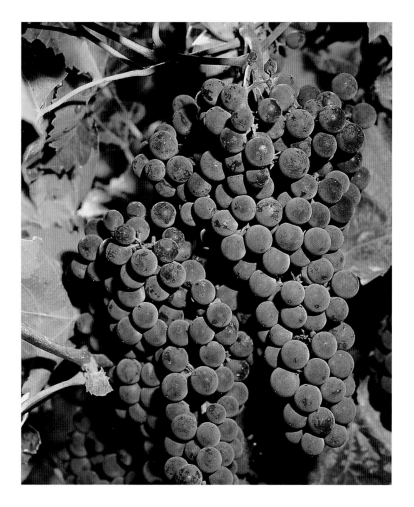

Although the region's white wines are better known, the number of high-quality red wines continues to grow.

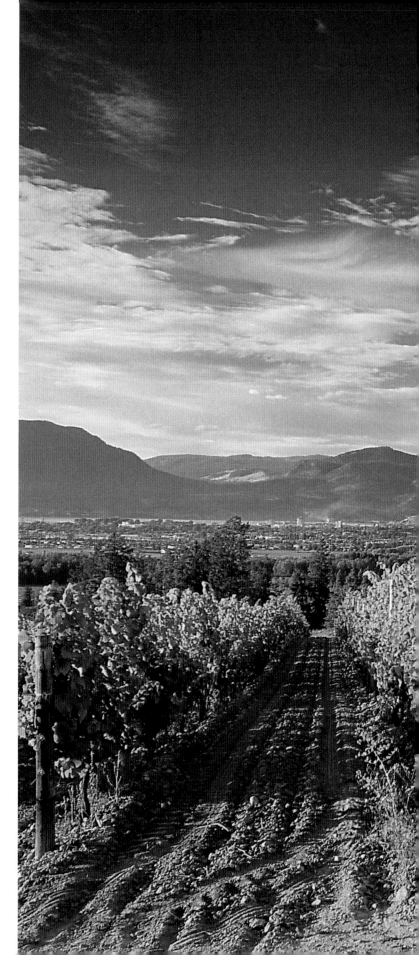

The Okanagan boasts more than 30 commercial, estate, and farm-gate wineries.

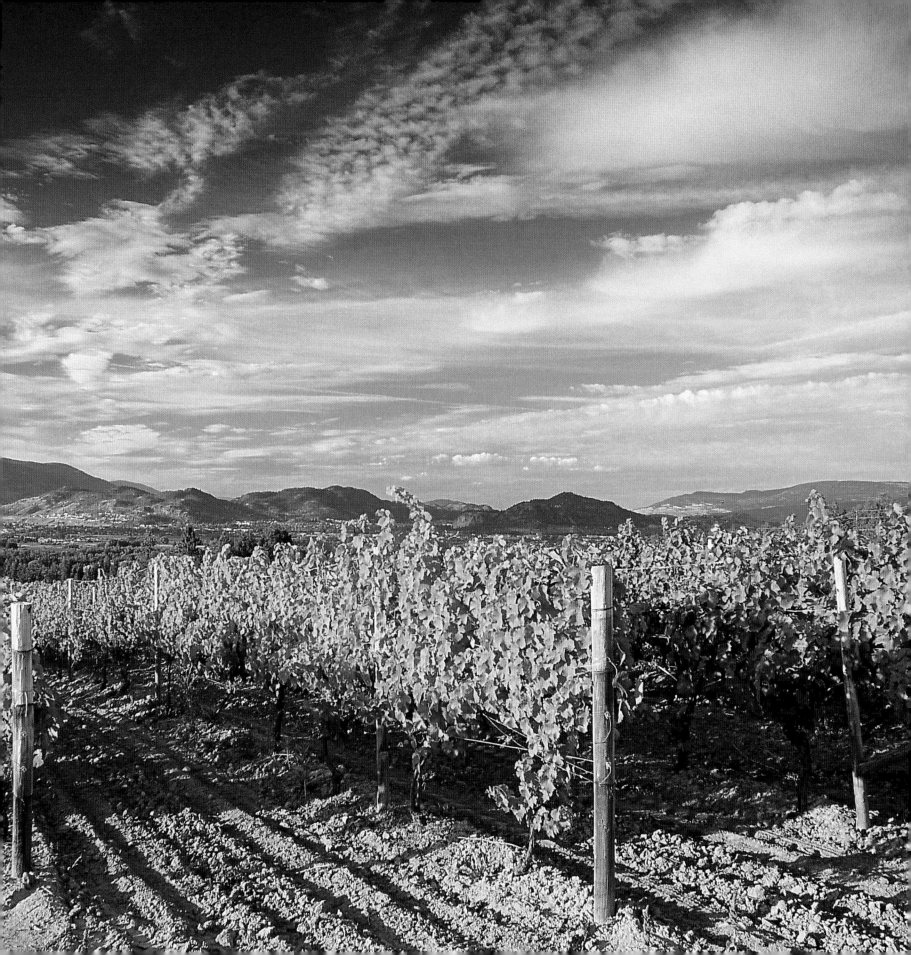

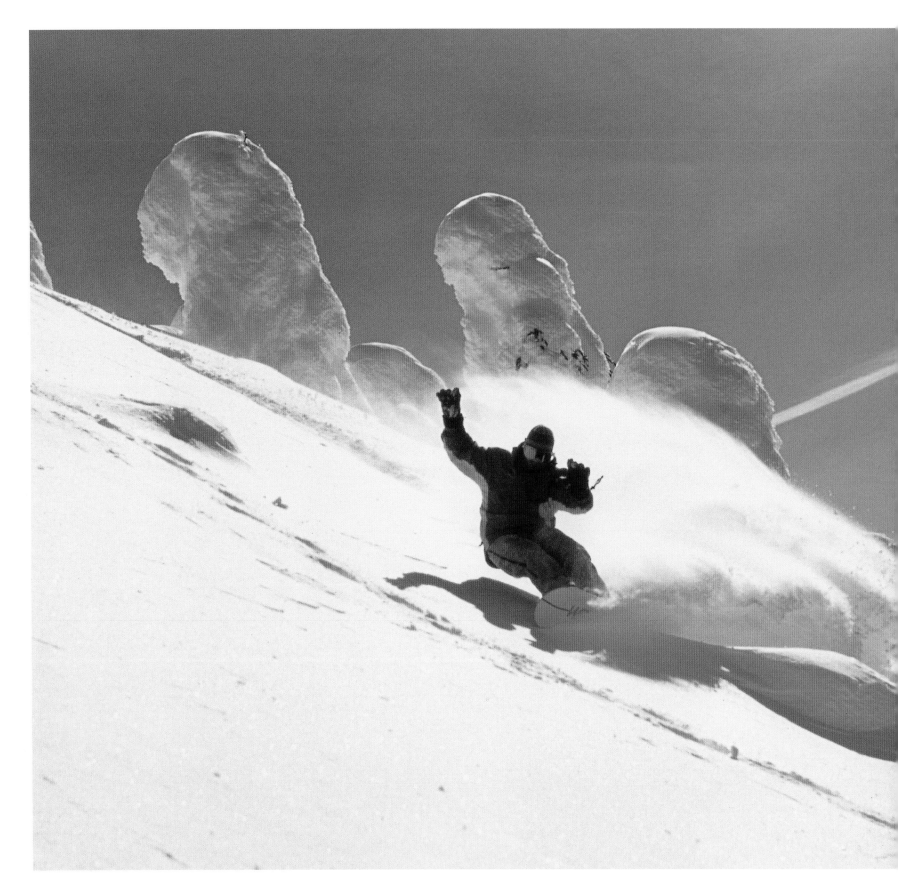

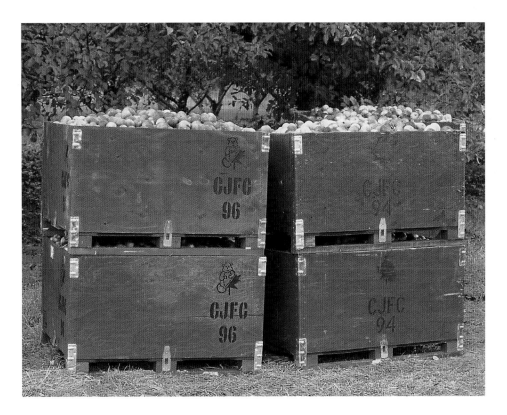

After more than 150 frost-free days, the Okanagan apple harvest begins. Apples are shipped throughout the province and around the world.

Recently expanded, Big White Ski Resort boasts the county's highest detachable quad chair. Groomed runs and untouched expanses of powder combine to make this one of the Interior's most popular ski hills.

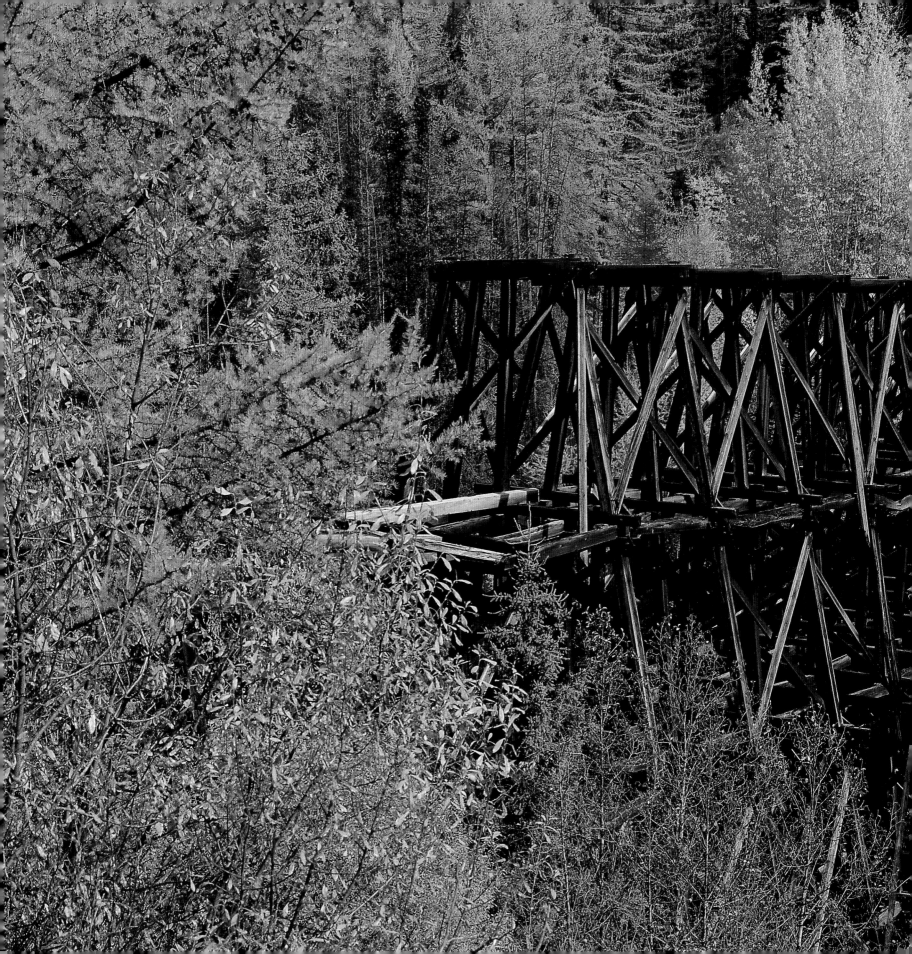

One of the most expensive railway lines ever constructed, the Kettle Valley Railway was built to connect the gold fields of the Interior with the coast. Much of the historic line is now a cycling and hiking destination.

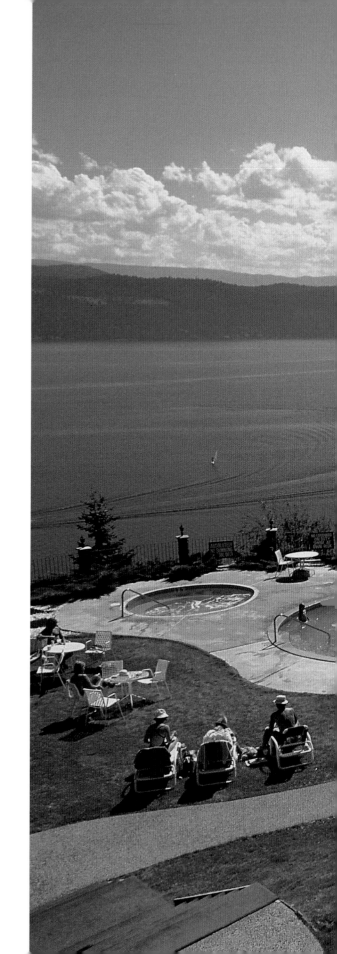

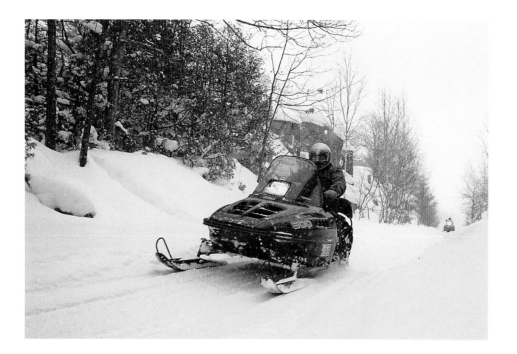

Snowmobilers frequent the summits around the valley, travelling through pristine winter scenery.

At Lake Okanagan Resort, guests can spend the entire day by the pool or choose from a myriad of activities: sailing, tennis, horseback riding, and more. Sunday brunch or dinner at the Chateau Dining Room are also popular attractions.

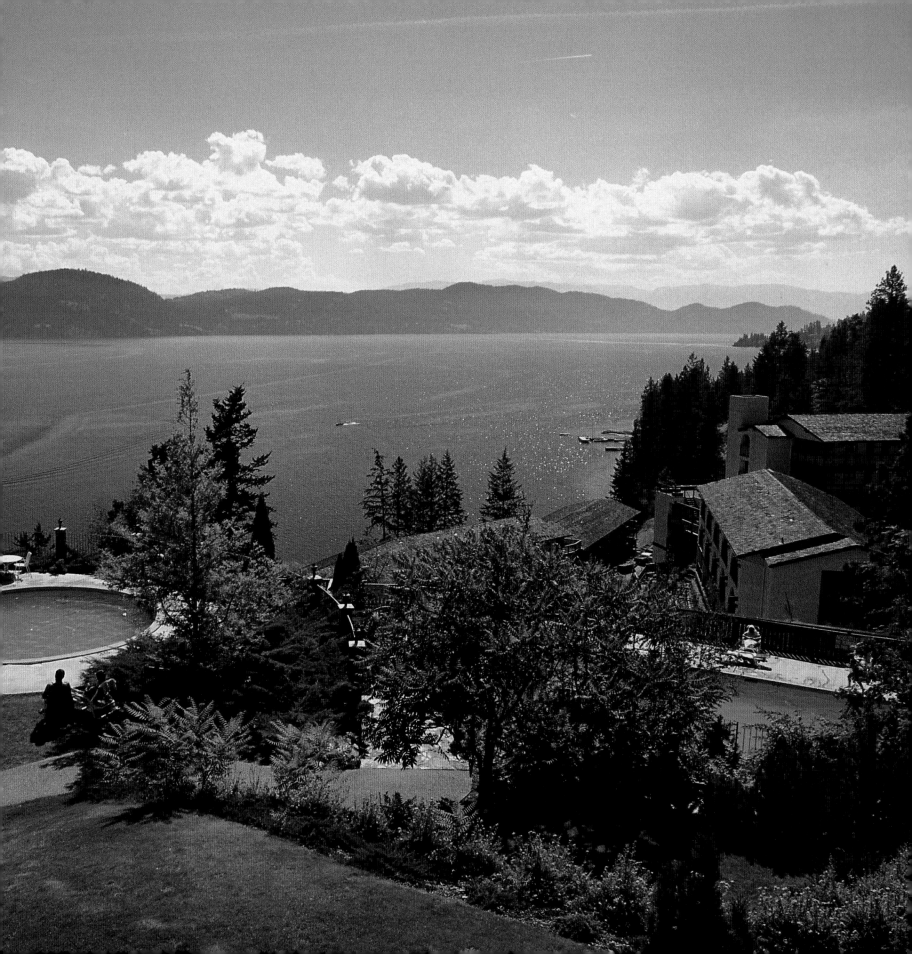

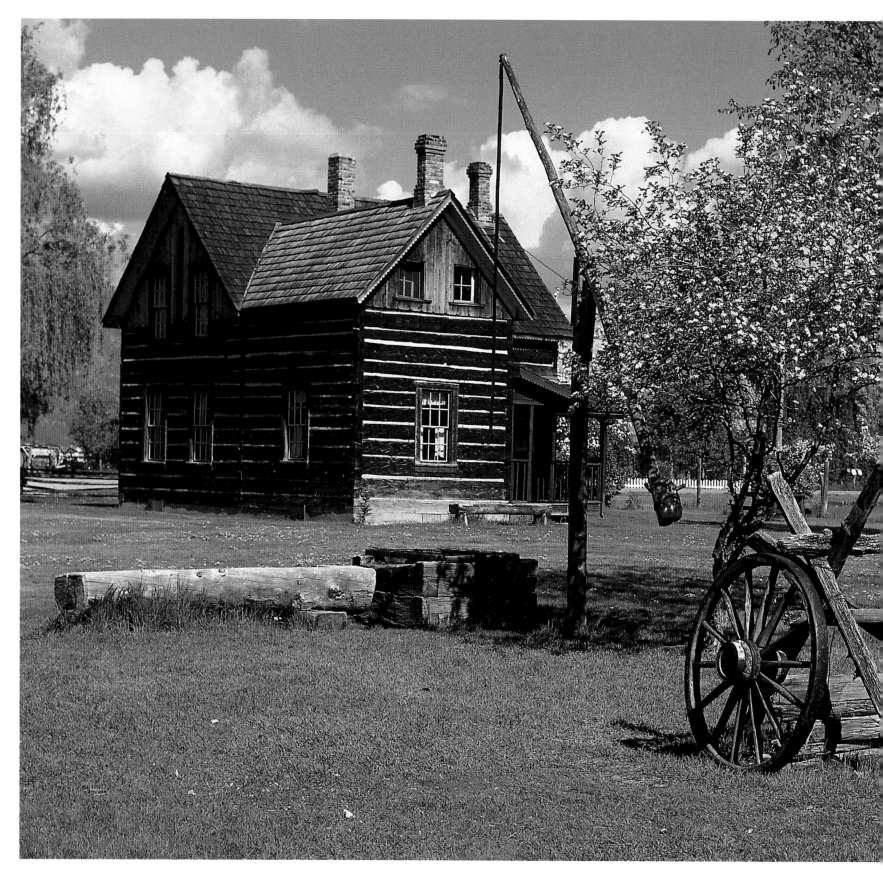

The mission was restored in the 1950s and designated a historical site in 1983.

Father Charles Marie Pandosy, an Oblate priest, founded the first Roman Catholic mission in the Interior and the first European settlement in the Okanagan. In 1859–60, he and a small group of missionaries built the area's first school.

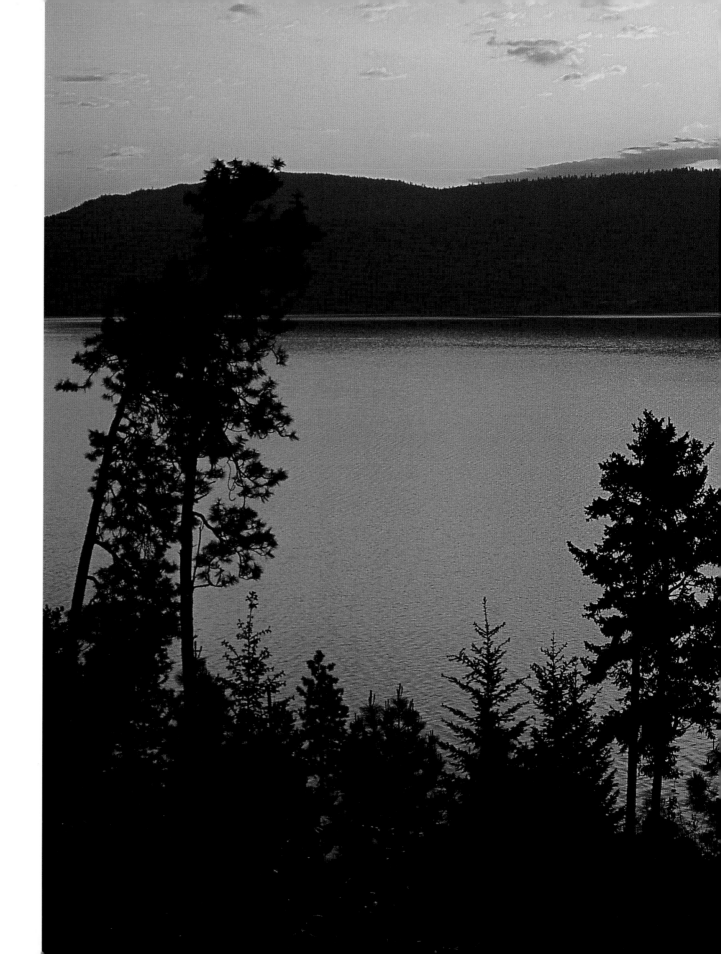

A moment of still-ness descends over Okanagan Lake at dusk.

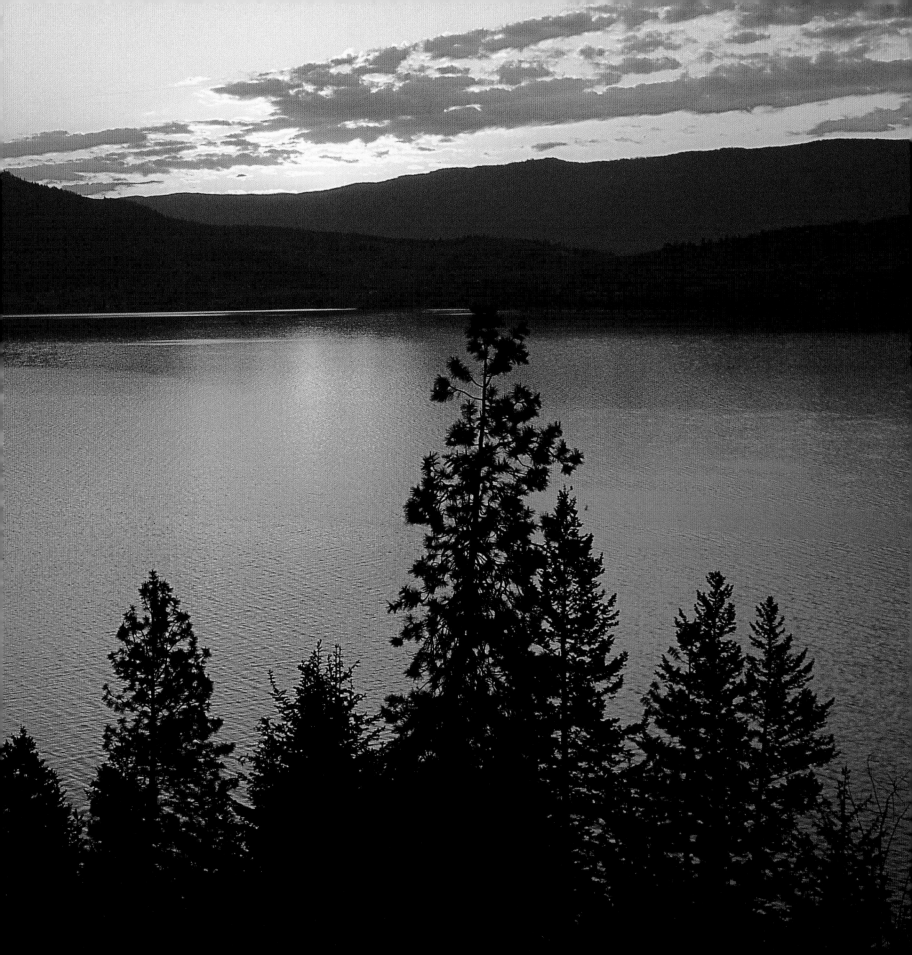

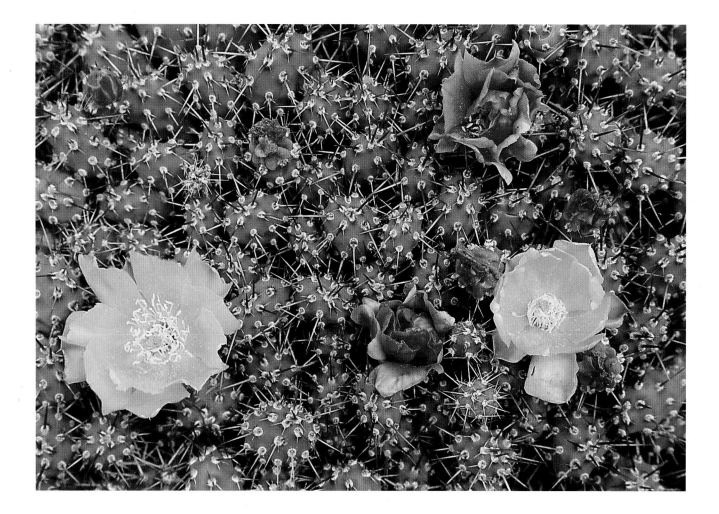

The prickly pear cactus abounds in the Okanagan, along with other desert plants such as greasewood, sage, and rabbitbrush.

Geologists disagree about the formation of Pinnacle Rock. Some say it was carved by erosion, while others believe the lava spire split from the side of the wall behind it.

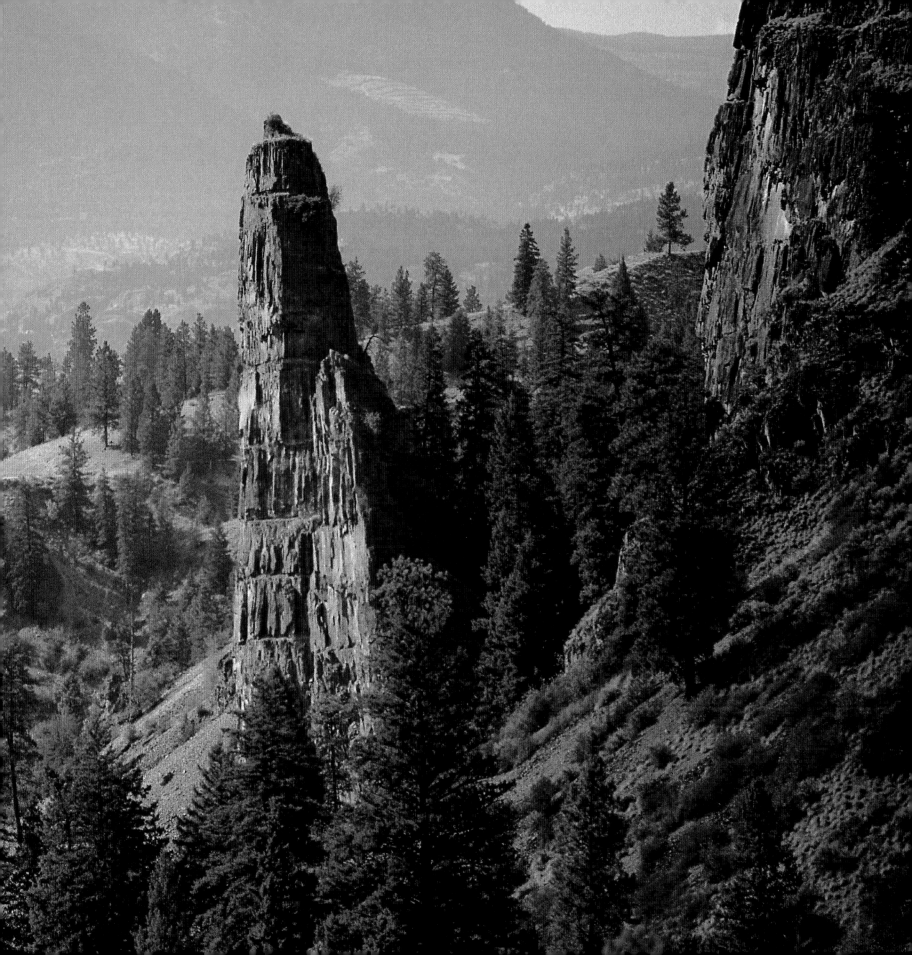

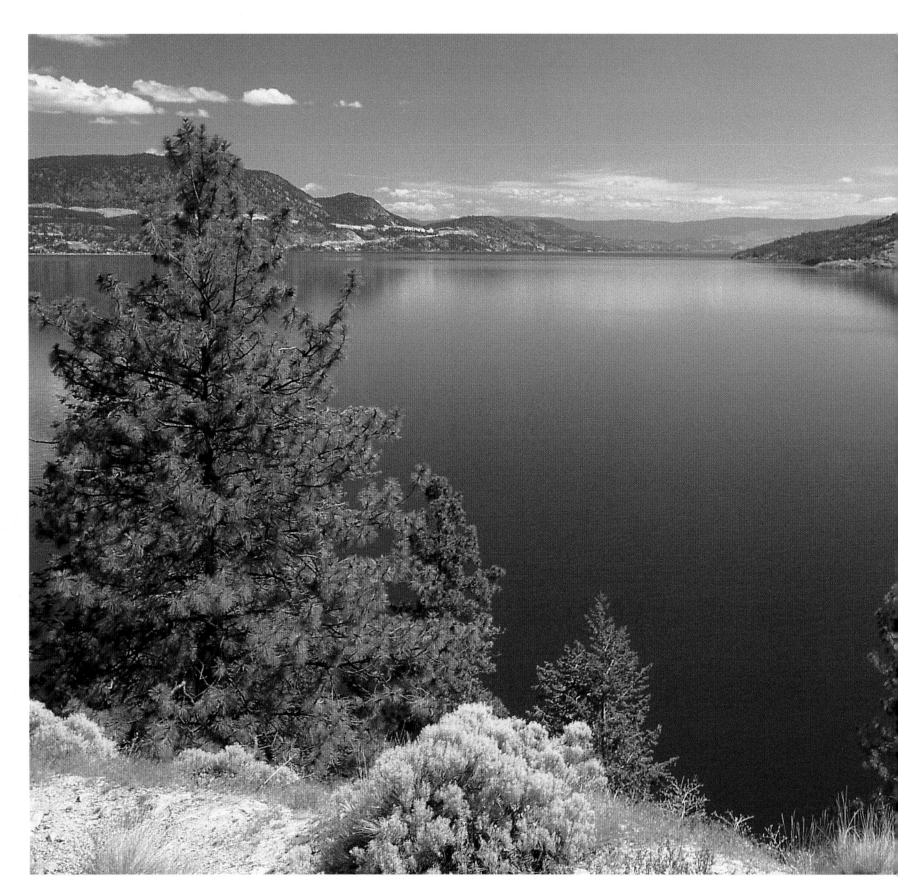

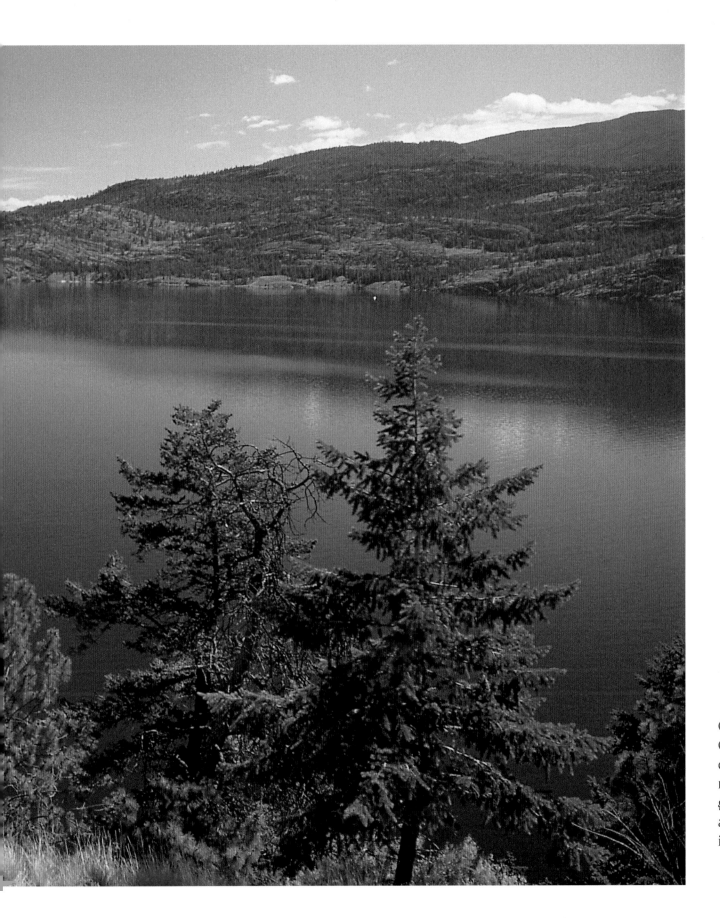

Okanagan, Kalamalka, Osoyoos, and the other valley lakes are remnants of a huge glacier lake created at the end of the last ice age.

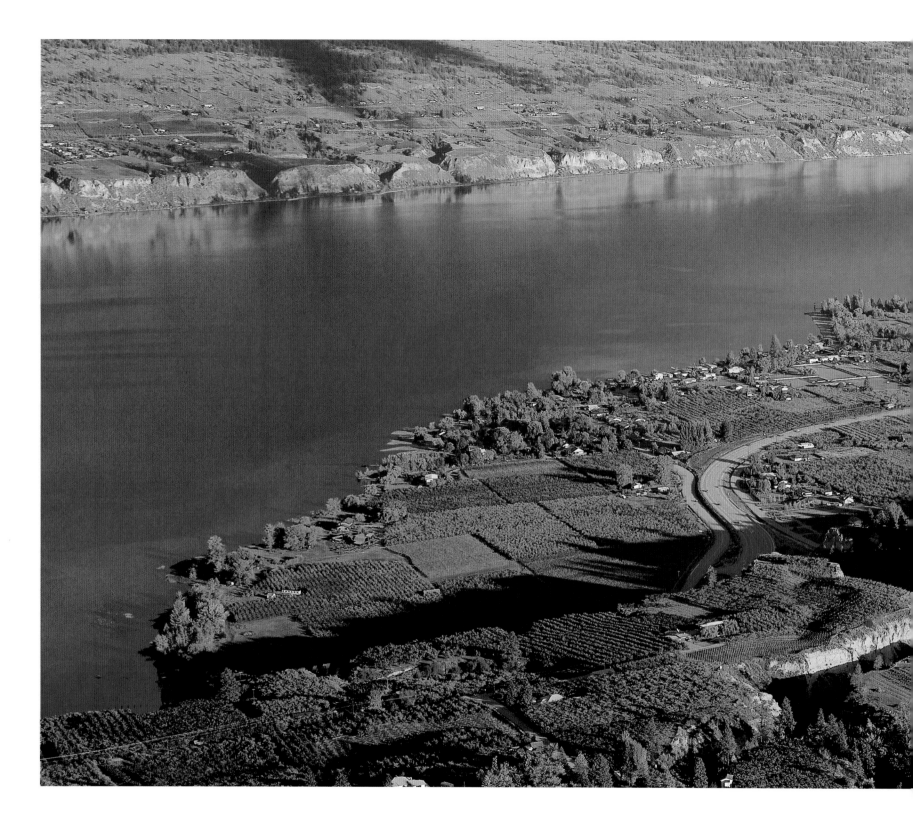

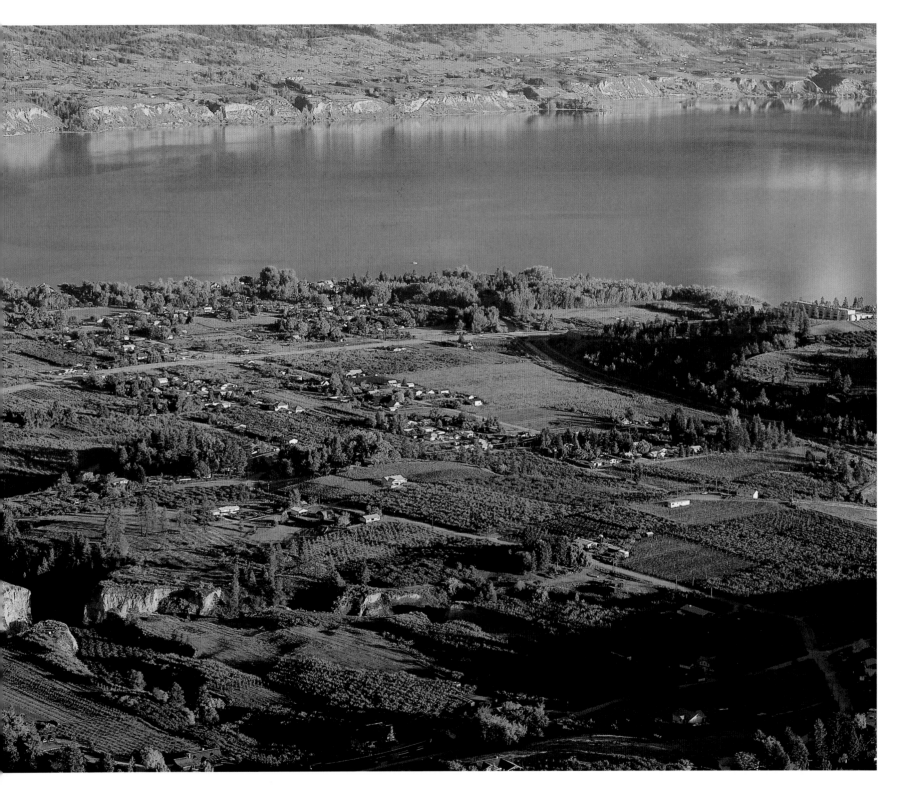

The Spartan apple and other varieties were developed at the Summerland Research Station. The station has also contributed greatly to research on tree diseases and pest control. Across the lake lies the picturesque village of Naramata.

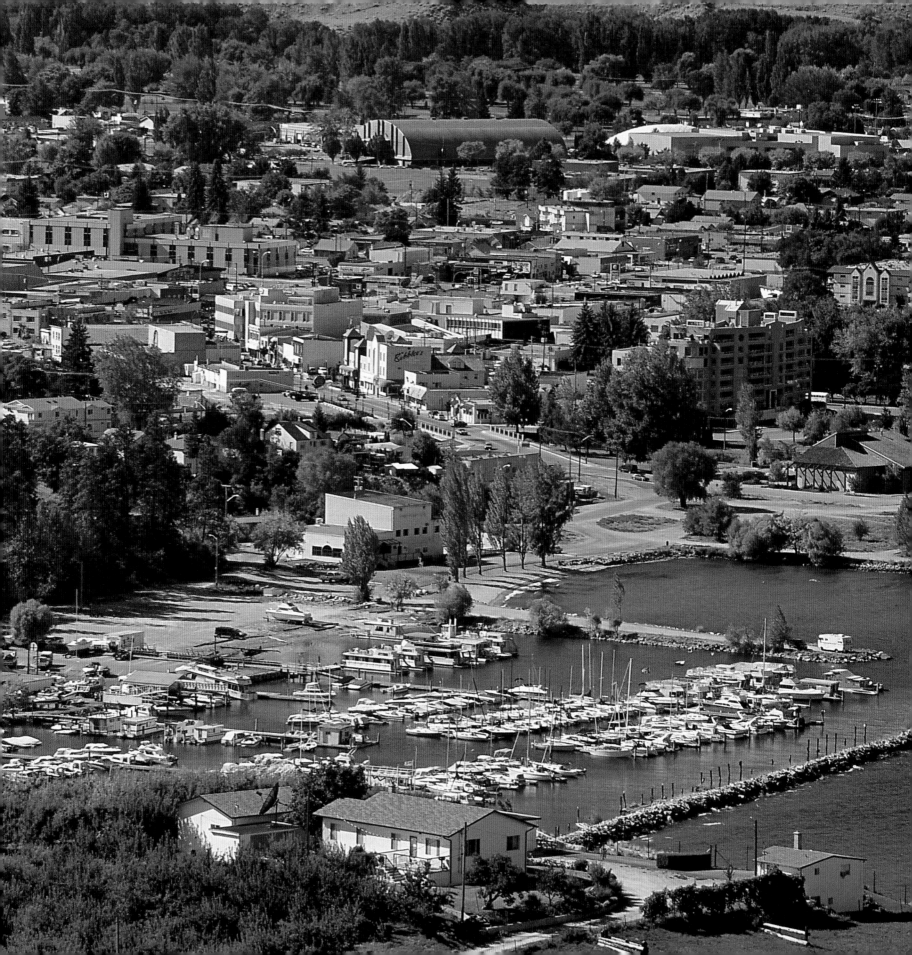

Summerland was the first town in the region to have electricity, and one of the first with large-scale irrigation. Much of this was the work of developer John M. Robinson.

A city on a delta, Penticton is built on a 3.5-kilometre (two-mile) stretch of silt that separates Okanagan and Skaha lakes. After Kelowna, this is the region's largest city.

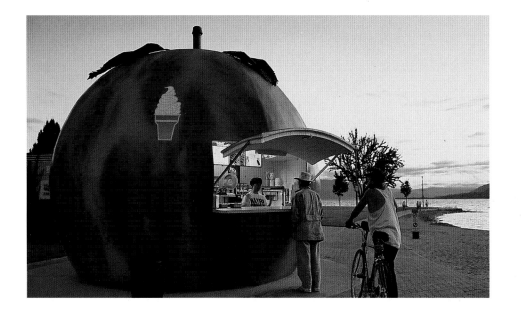

The population of the Okanagan region doubles in the summer, as visitors flock to the beaches, parks, and wineries.

PENTICTON
OUR FAVORITE →
BEACH

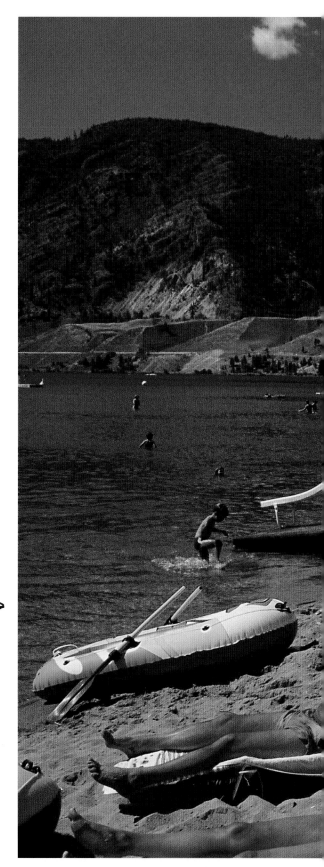

One of the region's largest sandy beaches makes Skaha Lake a favourite with children.

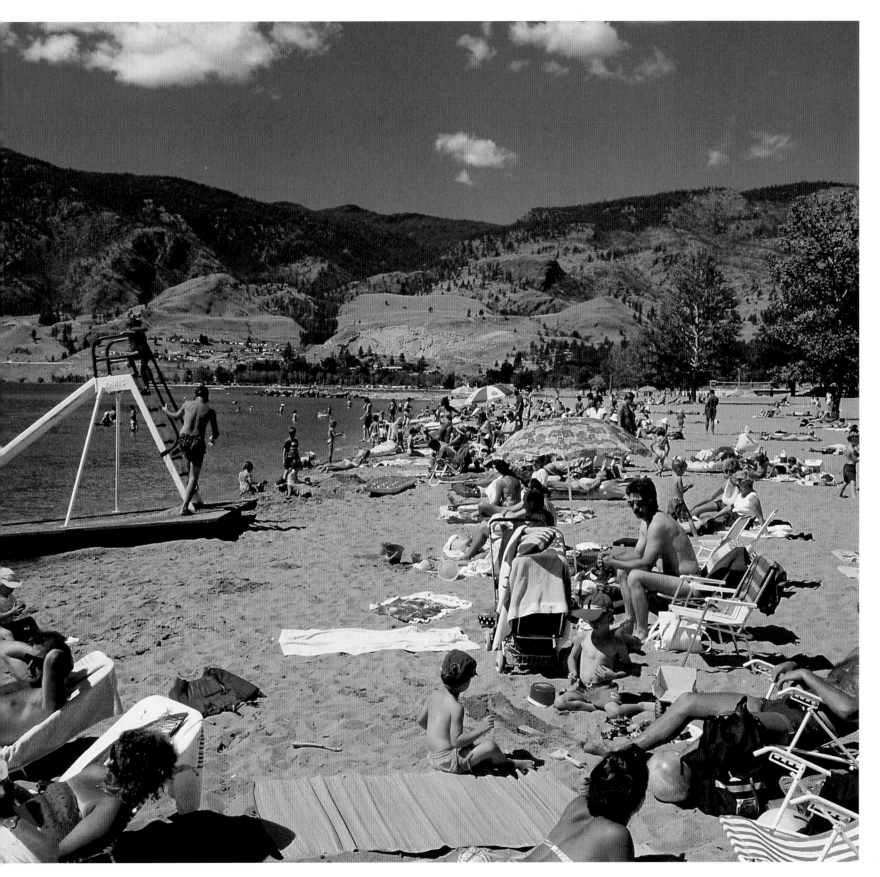

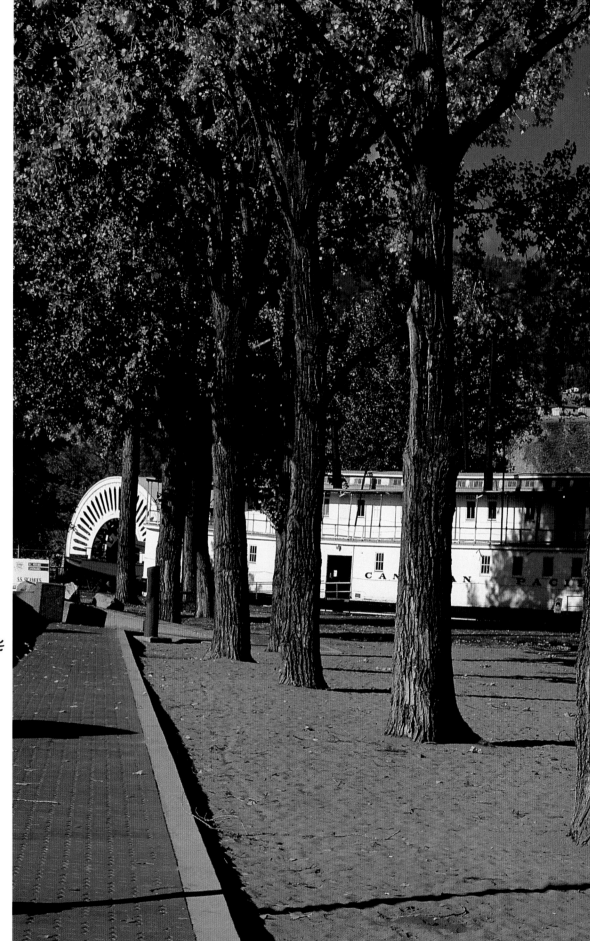

PENTICTON:
ACROSS FROM
MOTEL WHERE
I LIVED

The SS *Sicamous* once offered
luxury accommodations and could
carry up to 500 people. Until the
1930s, the sternwheeler ferried
passengers and freight to and
from the Kettle Valley Railway.

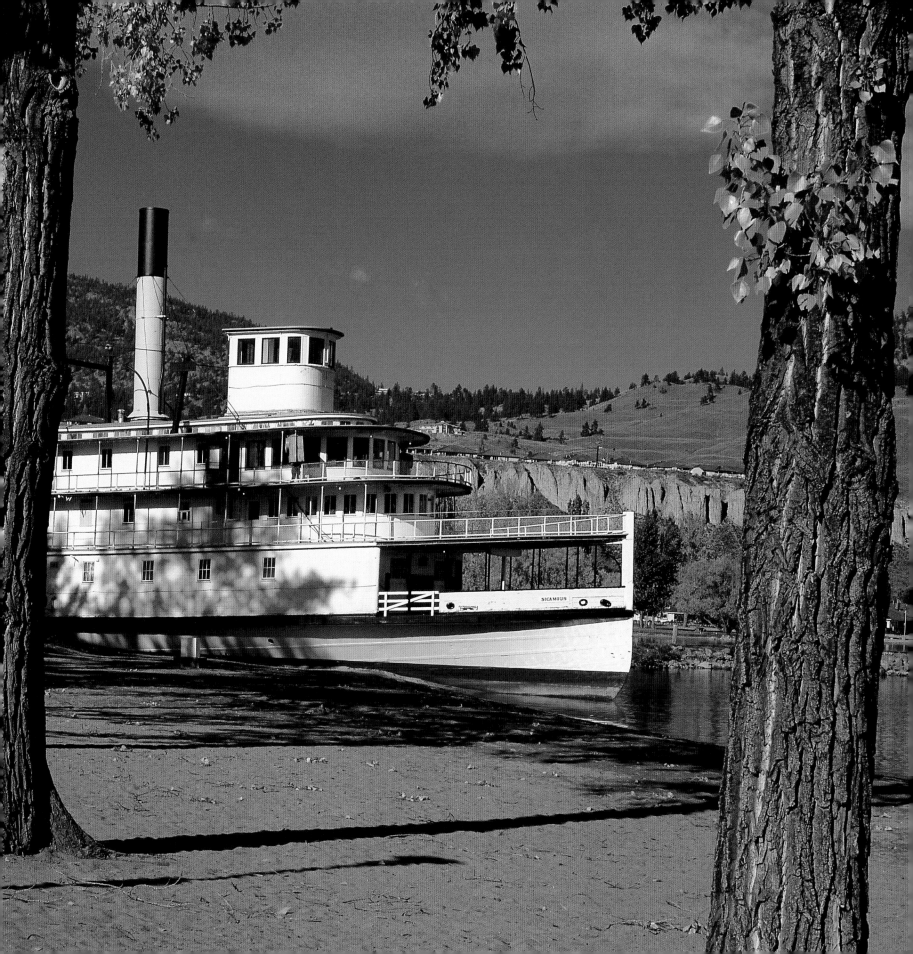

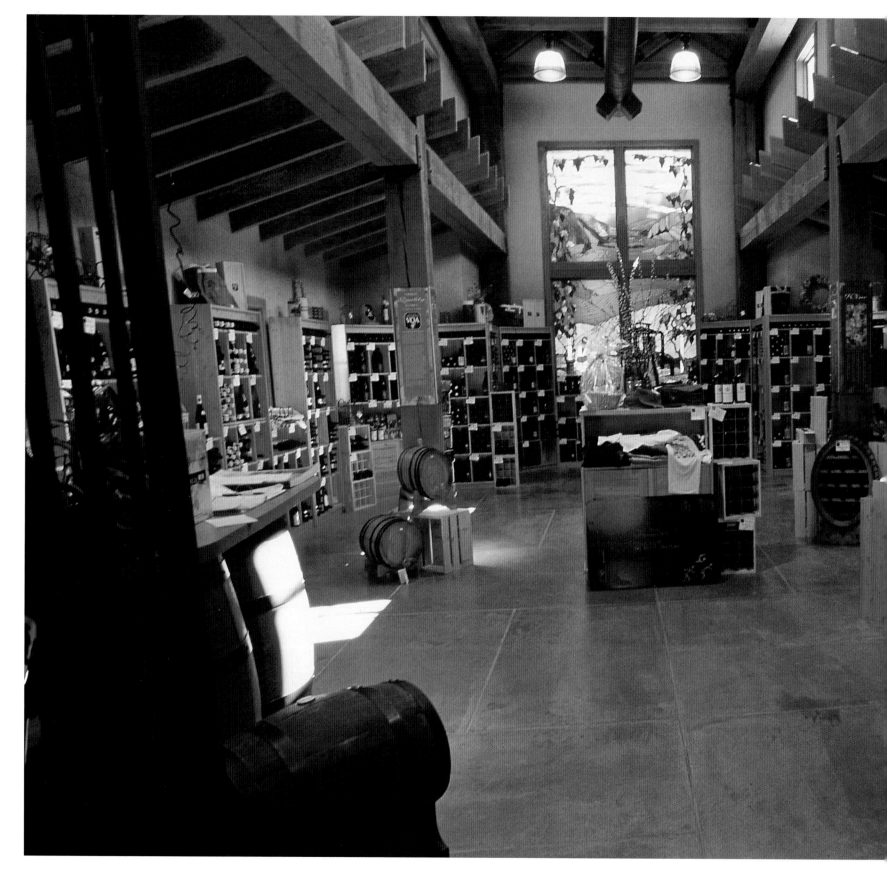

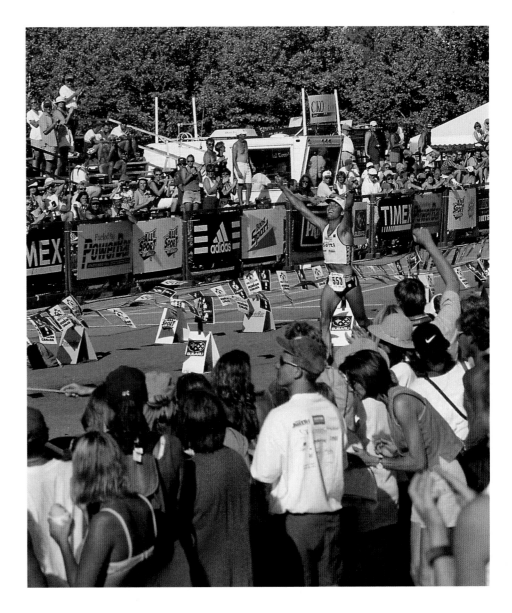

A gruelling 3.8-kilometre (2.4-mile) swim, 180-kilometre (112-mile) cycle, and 42-kilometre (26-mile) run, the Ironman Canada Triathlon draws competitors from more than 30 countries. The race is held in and around Penticton each August.

PENTICTON
^
The B.C. Wine Information Centre was created to educate the public about British Columbia wines. Some of the centre's activities include tastings, appreciation courses, and sales.

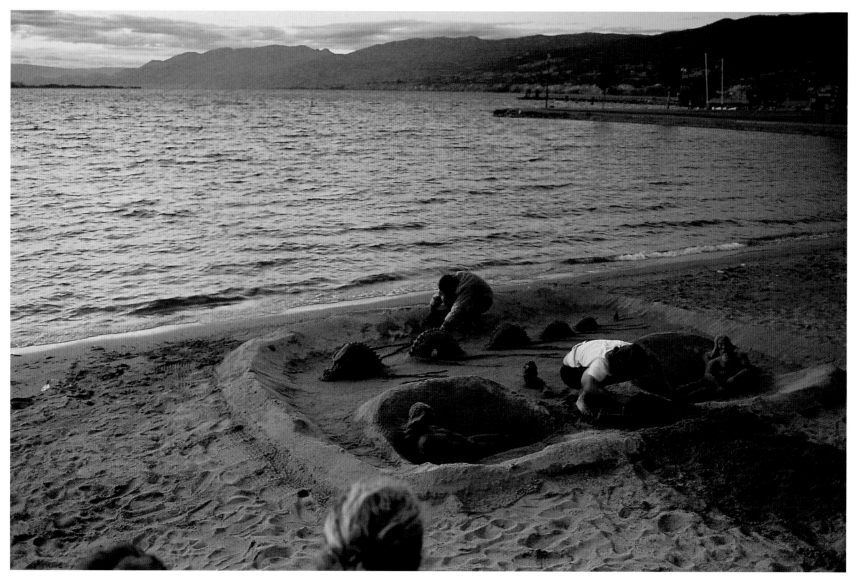

SKAHA LAKE

With more than 2000 hours of sunshine a year, Penticton is a recreational paradise. In the language of the area's First Nations, the city's name means "a place to live forever."

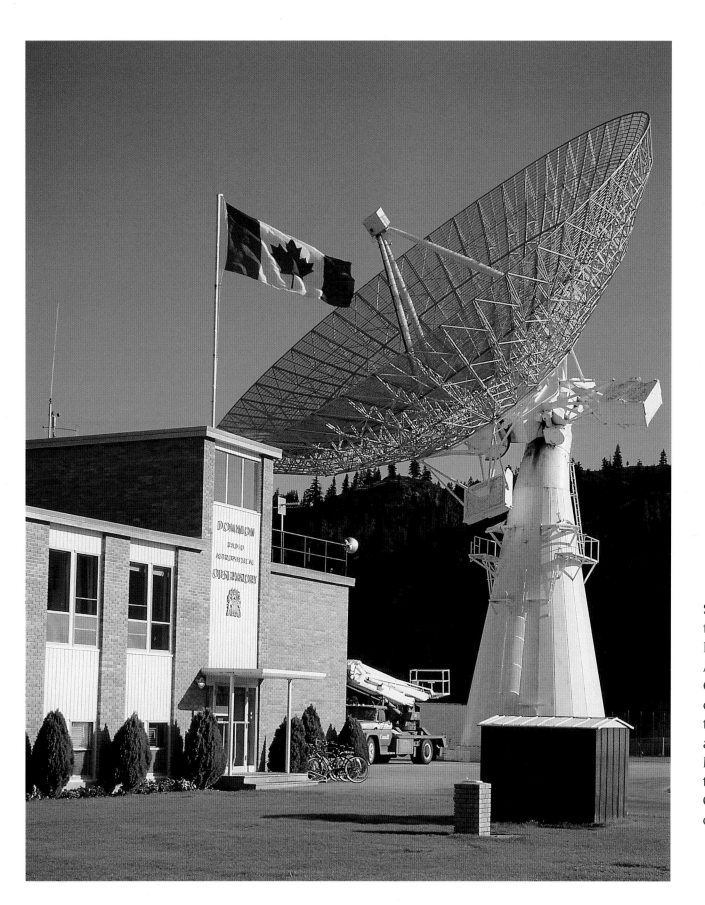

Scientists use the telescopes at the Dominion Radio Astrophysical Observatory, west of Okanagan Falls, to monitor the sun's activity and map the Milky Way. This is the only exclusively Canadian radio observatory.

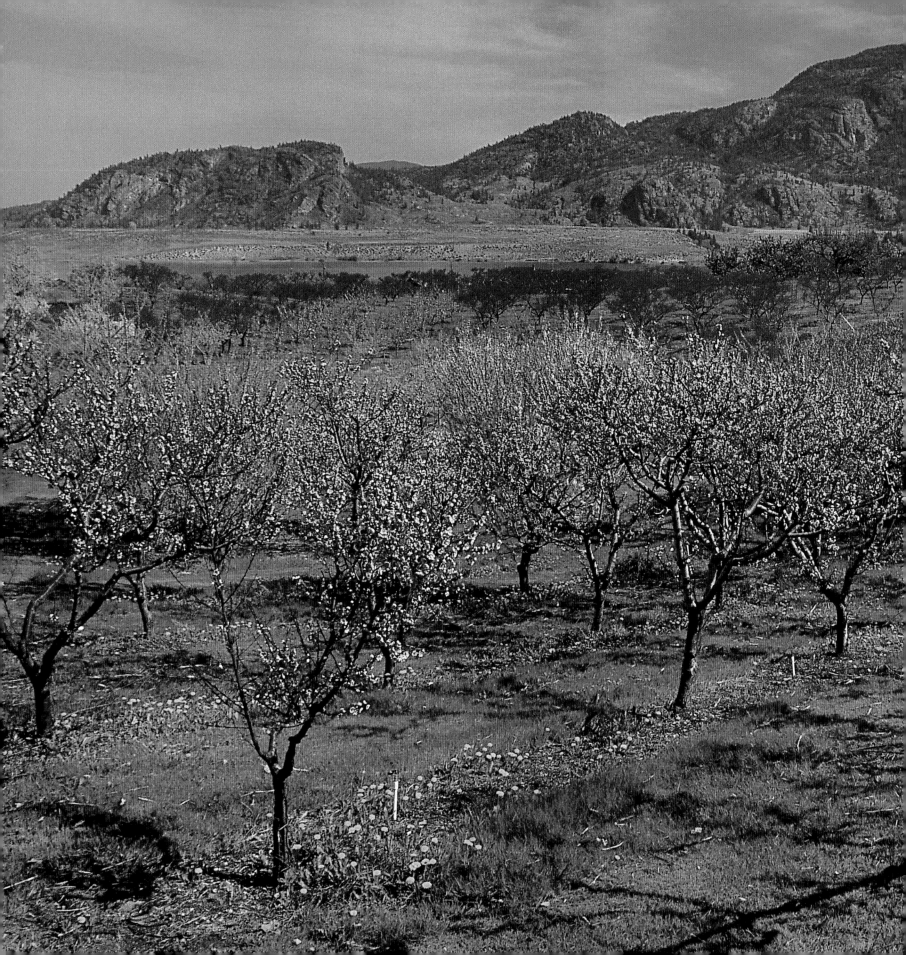

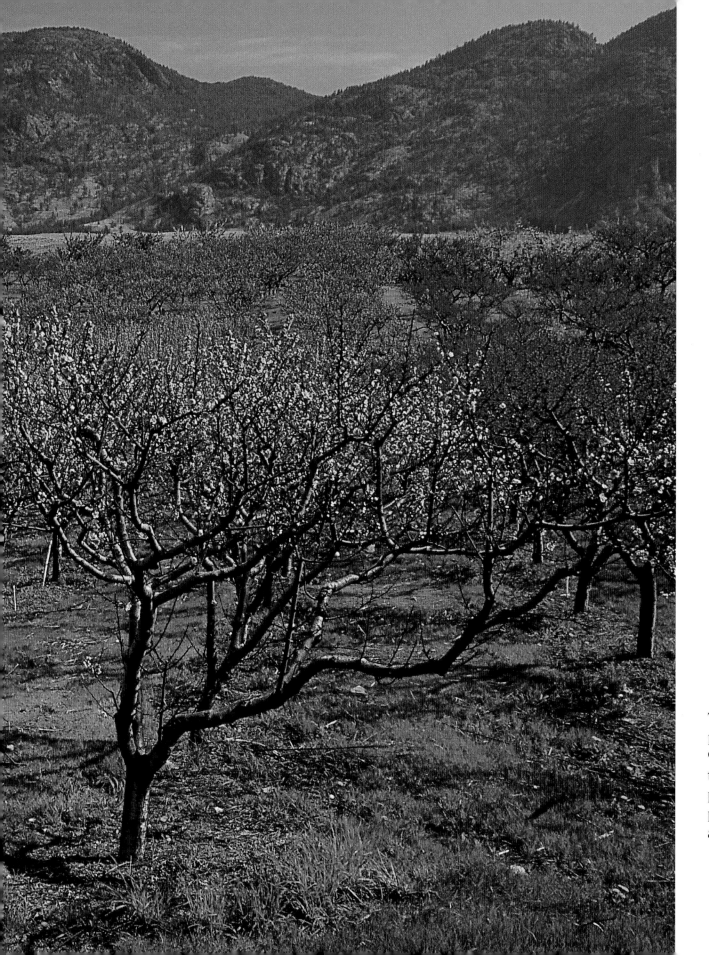

The Okanagan
produces more than
90 percent of Canada's
tree fruits: apples,
pears, peaches,
plums, apricots,
and cherries.



71

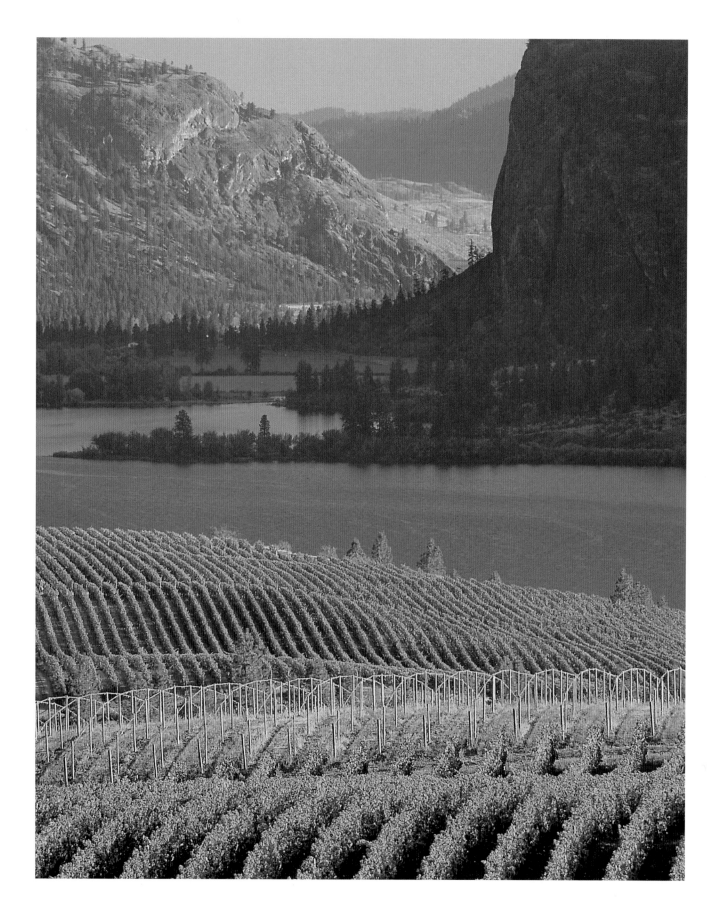

A vineyard overlooks Vaseux Lake. Vaseux means "muddy" or "slimy" and refers to the wetlands at the north end of the lake. The marshes here form part of a Federal Migratory Bird Sanctuary and are a major stopover for migratory birds in spring and fall.

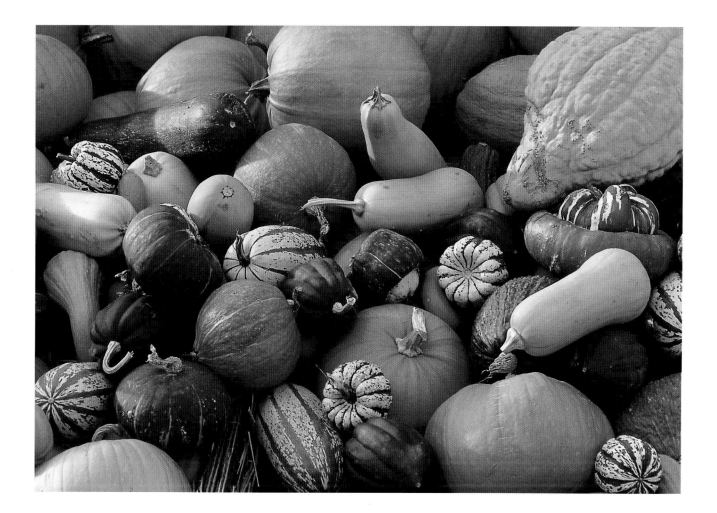

As well as filling fruit and vegetable stands throughout the valley, Okanagan produce is exported to more than 40 countries.

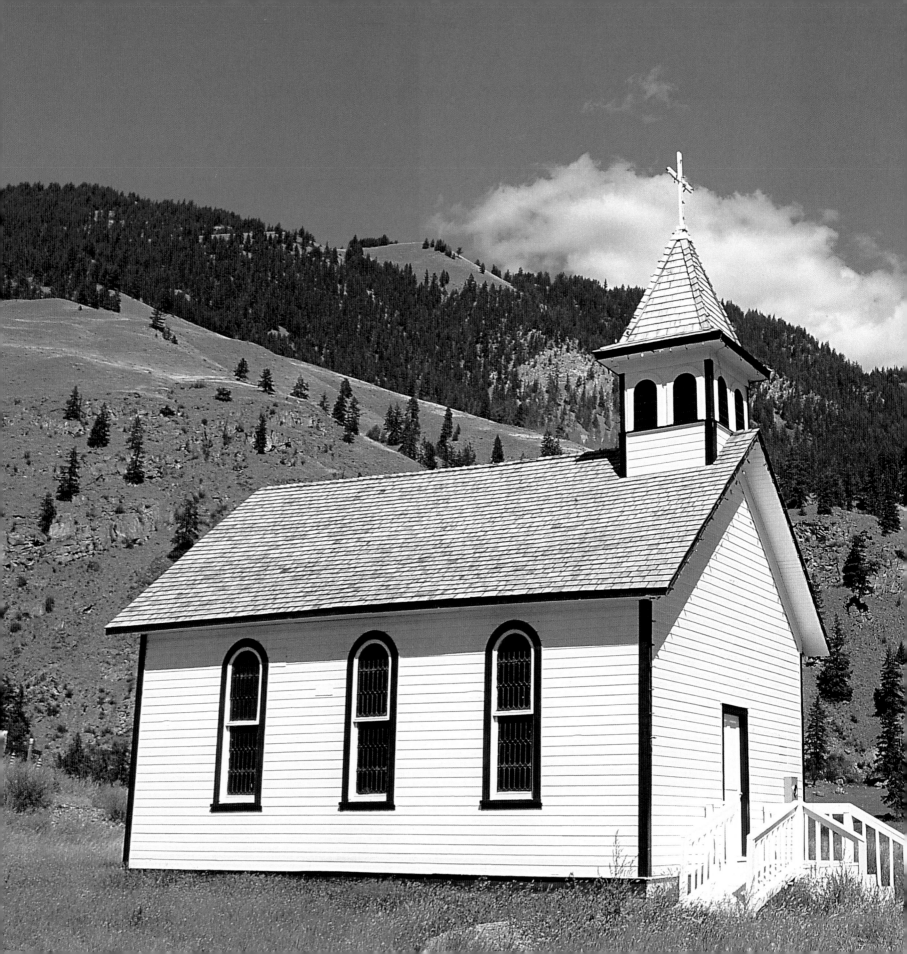

St. Ann's Church stands against a stunning backdrop west of Keremeos.

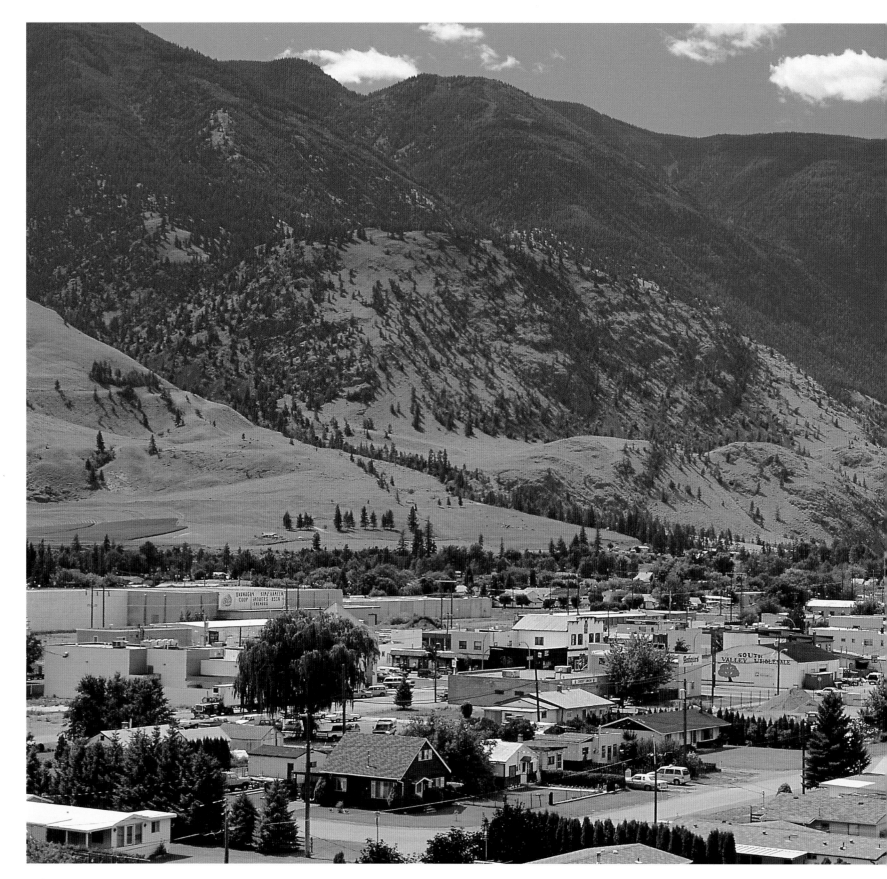

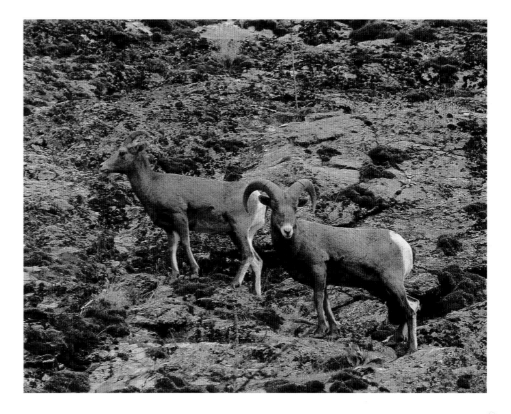

Bighorn sheep are a common sight in the mountains surrounding the valley, especially in the area around Vaseux Lake. These sure-footed ungulates grow a new ring on their horns each year.

Keremeos, the "fruit stand capital of the world," has offered produce to visitors since 1897, when settler Francis Xavier Richter planted the first commercial orchard.

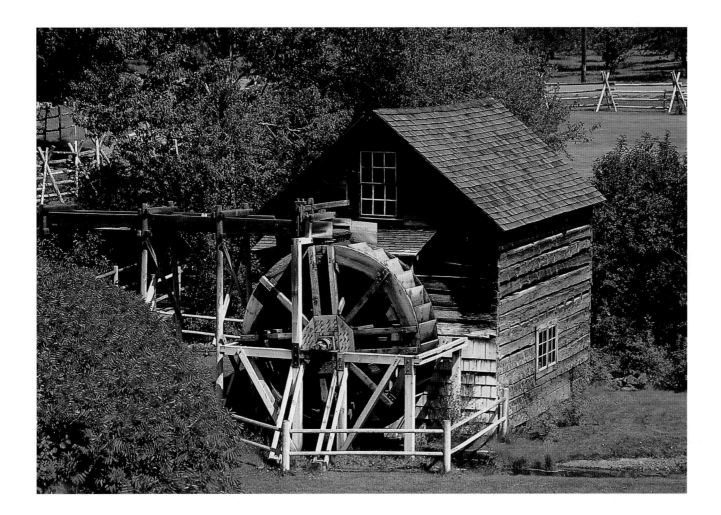

Canada's oldest flour mill, the Grist Mill in Keremeos, was built by Barrington Price in 1877. The heritage orchard on the property features 28 varieties of apples.

Granite monoliths loom in Stone City, one of the rugged ridges in Cathedral Lakes Provincial Park. The park, with trails connecting the five Cathedral Lakes, sharp peaks, and alpine meadows, encompasses more than 30,000 hectares (75,000 acres).

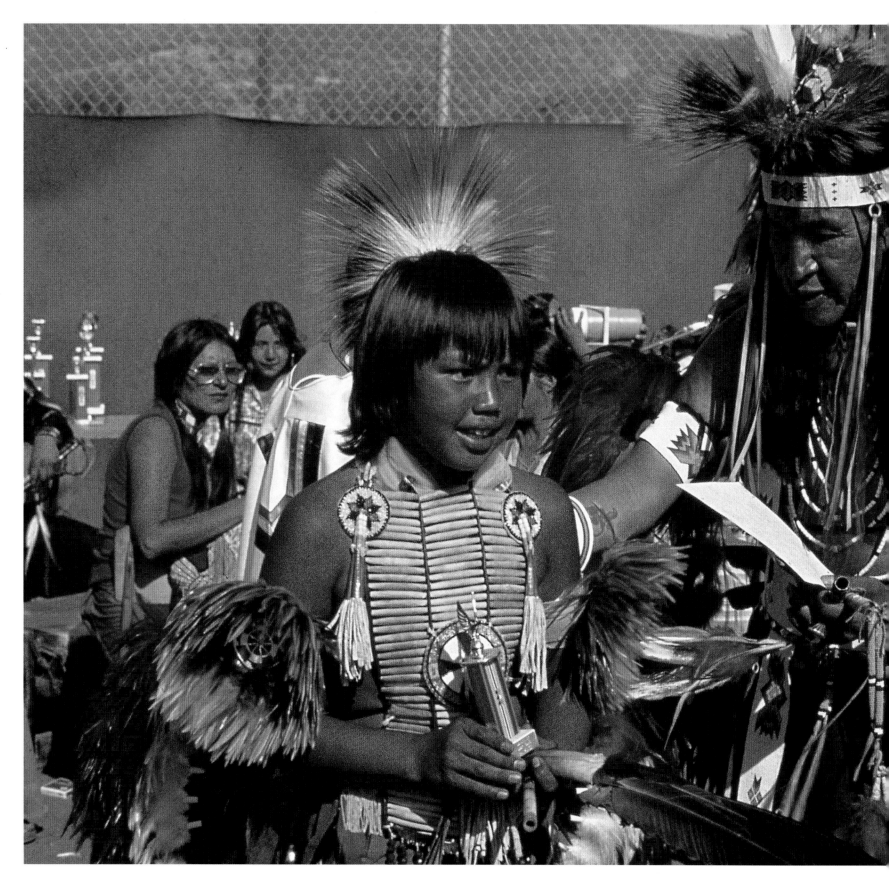

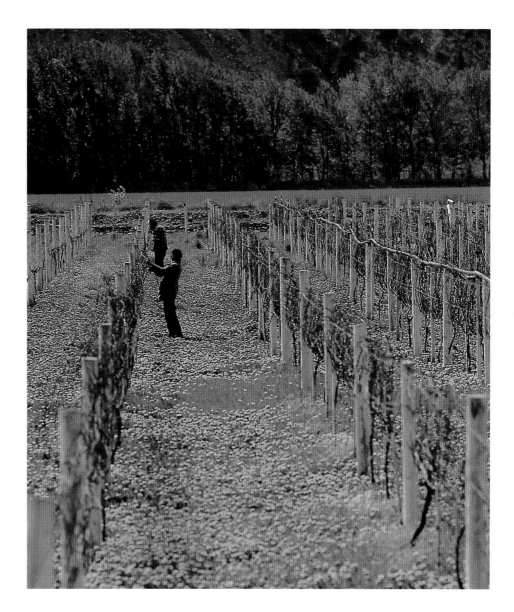

A vintner prunes grape vines in a sea of dandelions. Estate and farm-gate wineries grow most of the grapes they use. They also crush, press, ferment, and barrel age on site. While many commercial wineries produce wines using only B.C.-grown fruit, they are also permitted to import grapes.

Dancers continue the traditions of the Okanagan First Nations. Artifacts from before the arrival of Europeans have been found at archeological sites throughout the region — symbols of a time when this valley was home to about 12,000 native people.

Cascading flower baskets and Spanish-style architecture are part of what has earned Osoyoos the title of Canada's most beautiful small town.

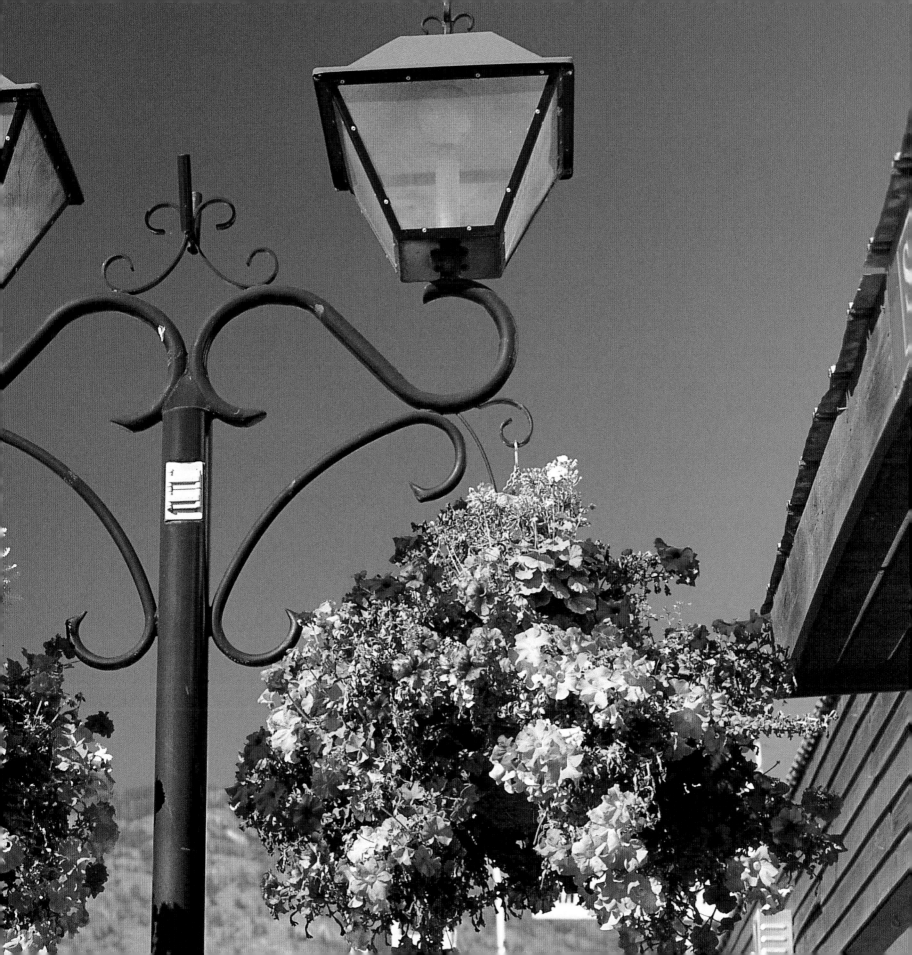

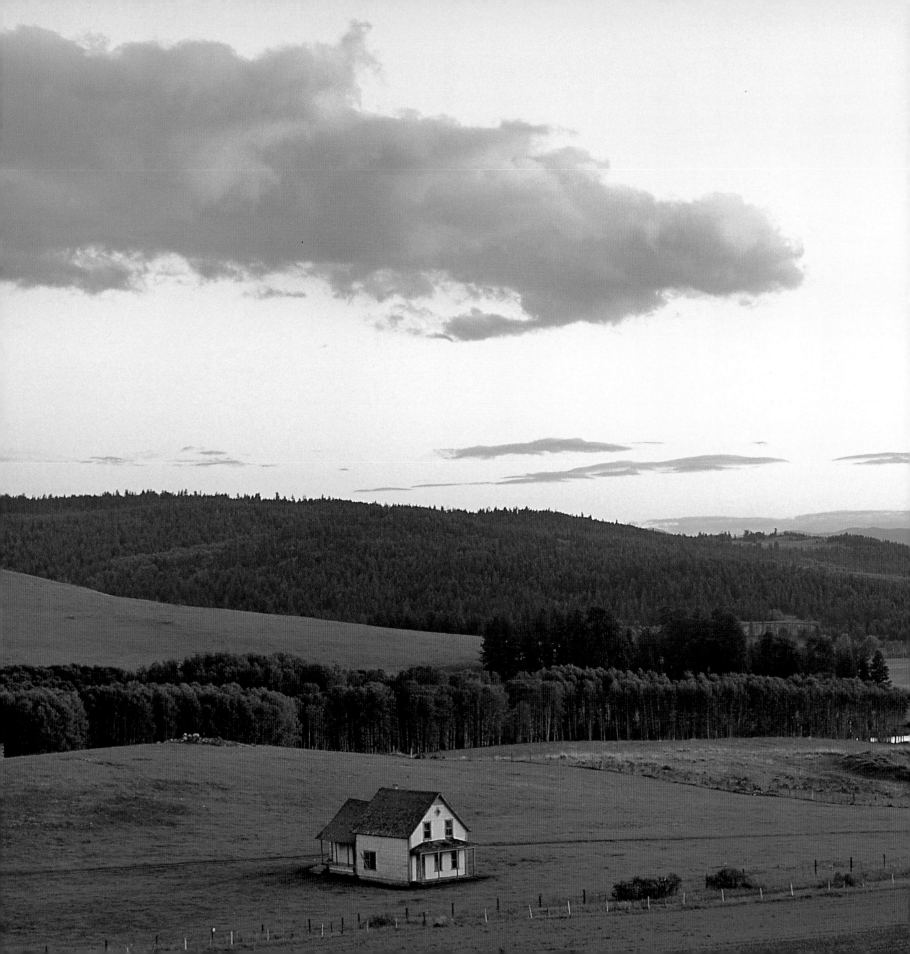

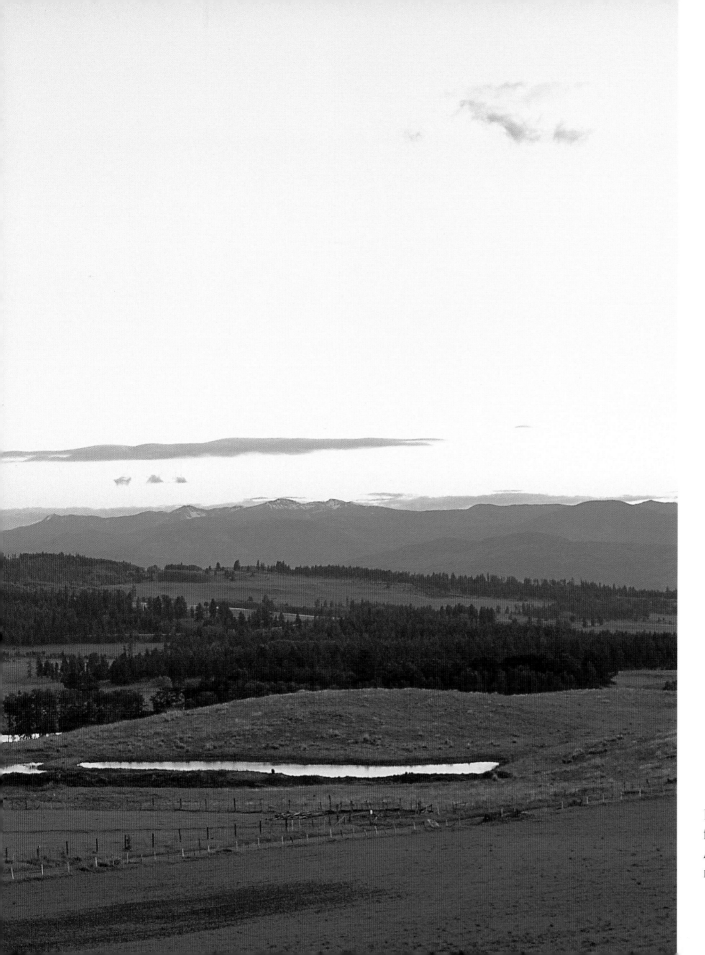

Farmland fans out
from the base of
Anarchist Mountain,
near Osoyoos.

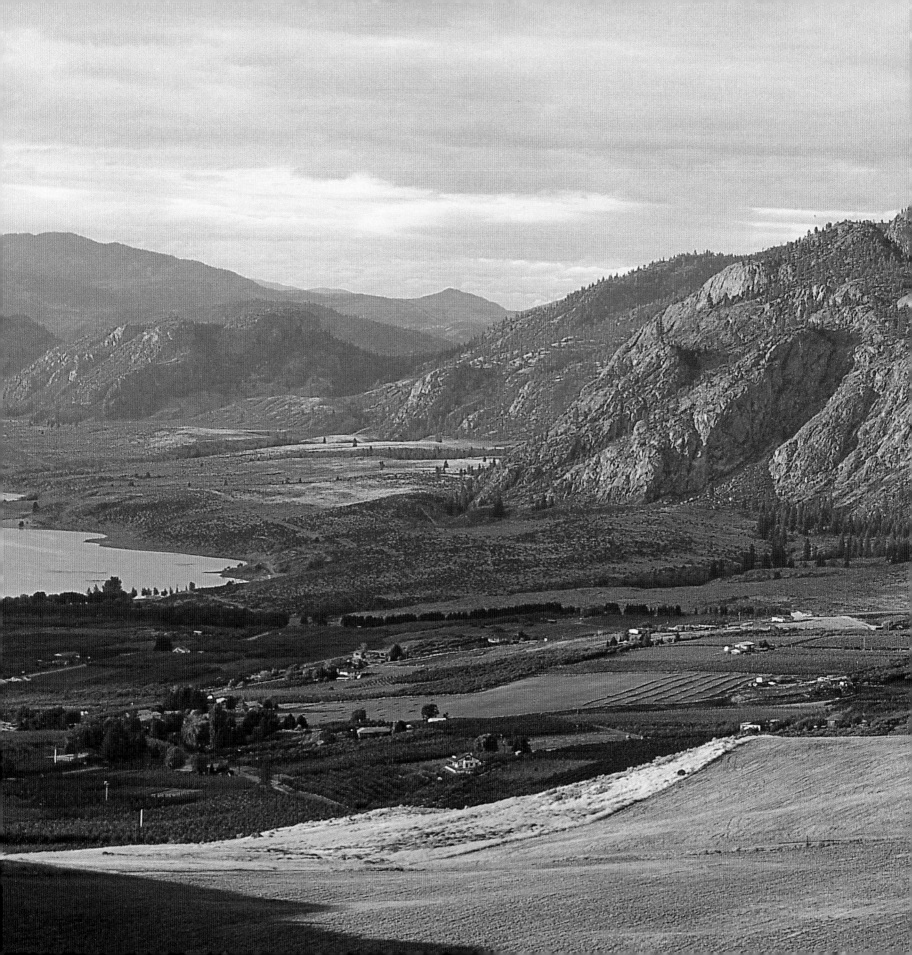

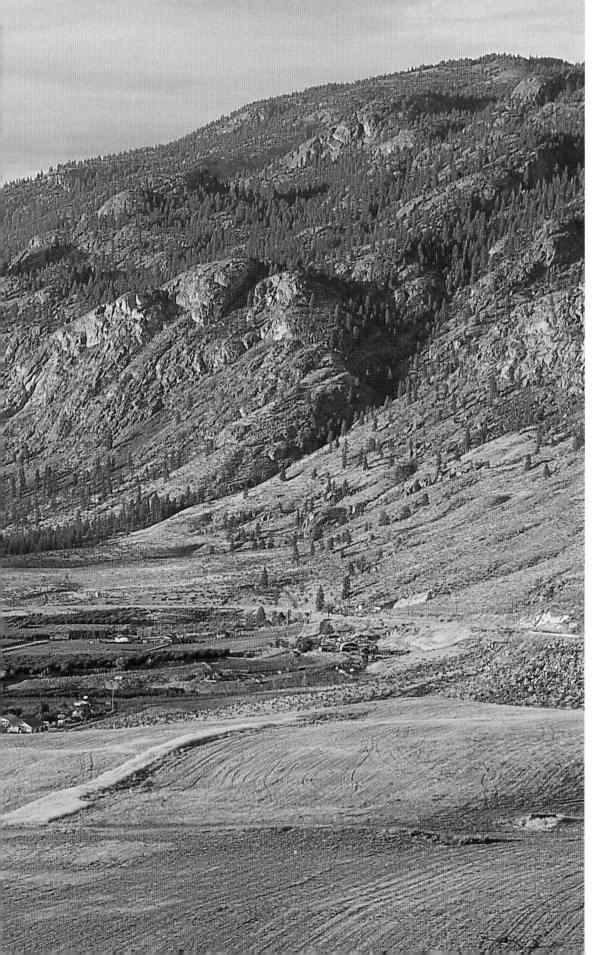

The Okanagan Valley runs
north-south between the Cascade
and Monashee mountains.

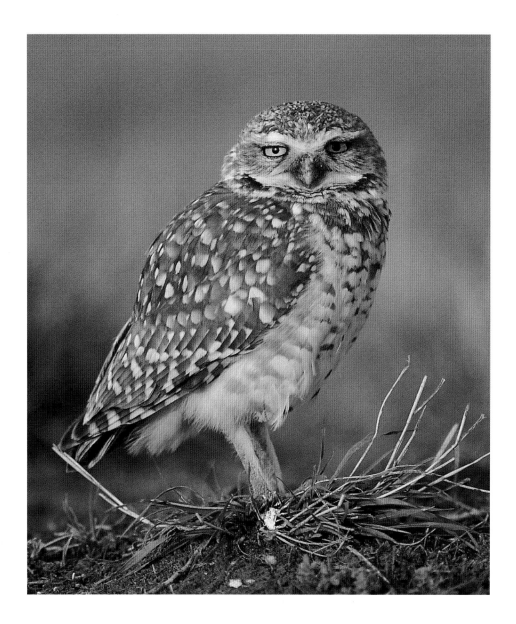

Burrowing owls, which nest in the deserted burrows of mammals, have a number of unique tricks. They are best known for imitating the sounds of rattlesnakes, to frighten off predators. The owls may also bring animal droppings into their nests to disguise their scent.

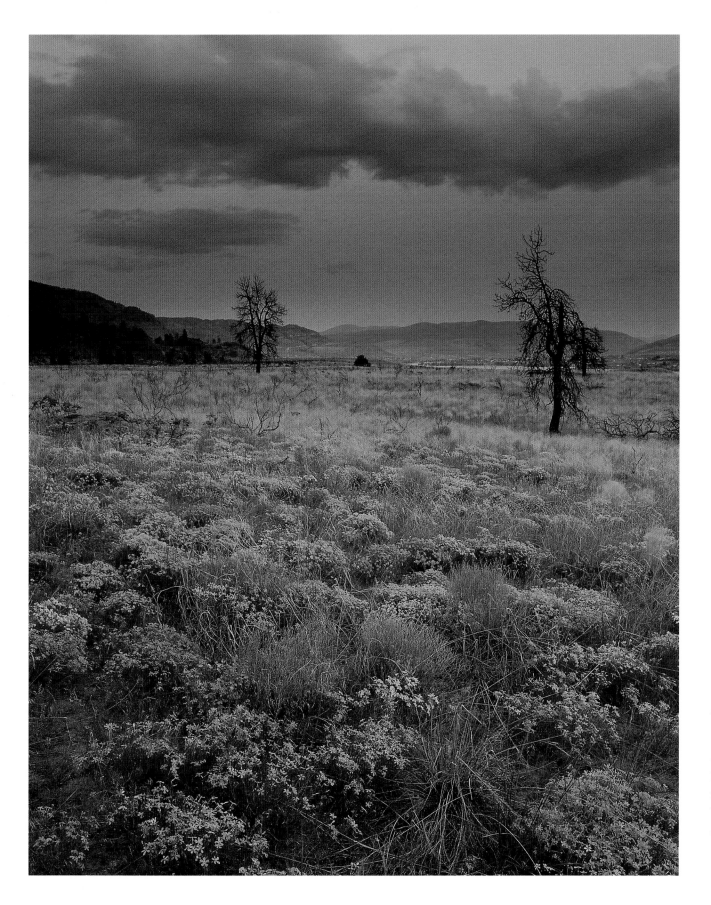

The Federal
Ecological Reserve
north of Osoyoos
is an important refuge
for the endangered
burrowing owl and
other desert species.

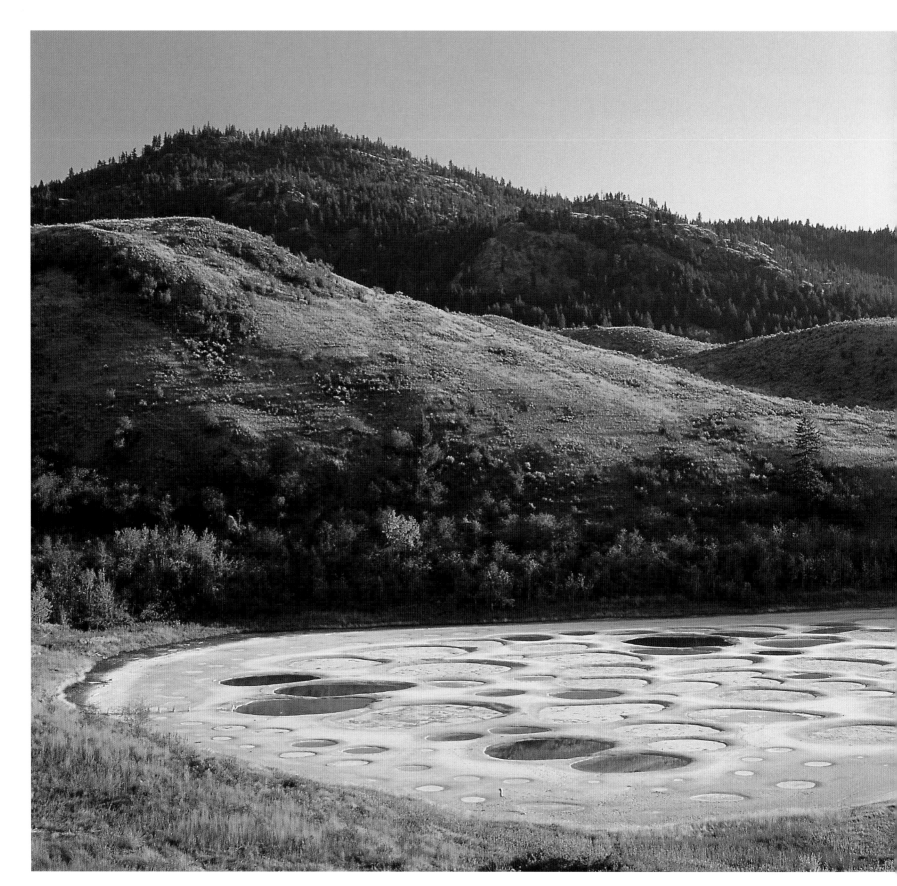

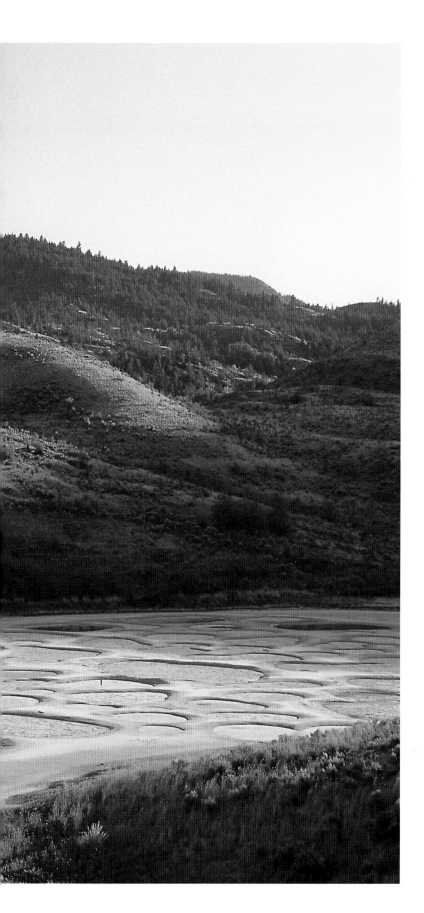

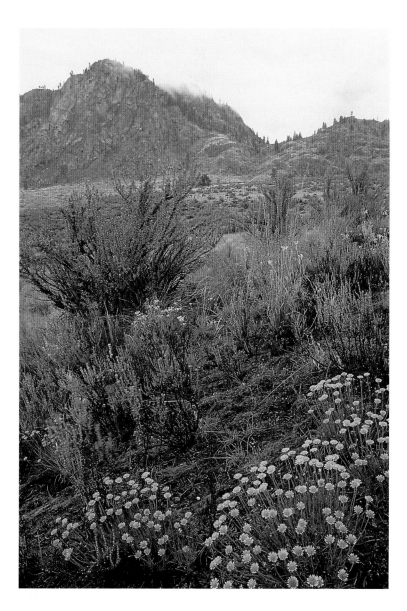

An extension of the American Great Basin Desert, the Pocket Desert gets less than 20 centimetres (8 inches) of rain annually. It is home to prickly pear cacti, lizards, bats, and species of plants found nowhere else in Canada.

As the sun speeds evaporation, the crystallization of naturally occurring calcium, magnesium, and Epsom salts patterns the surface of Spotted Lake.

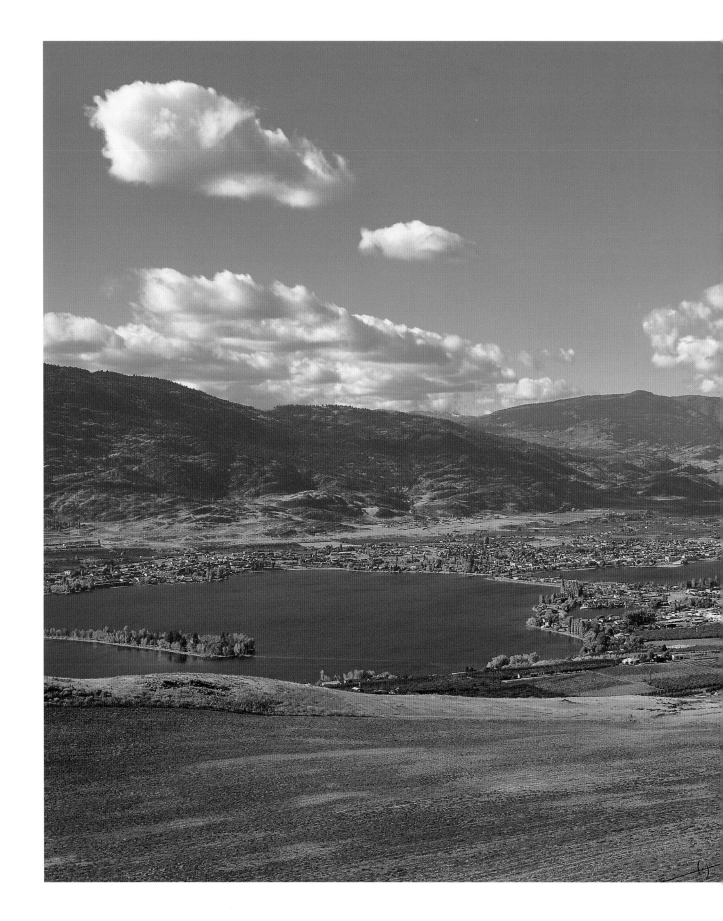

Osoyoos means "the narrows of the lake." The town spreads along the shores of Osoyoos Lake, the country's warmest freshwater lake.

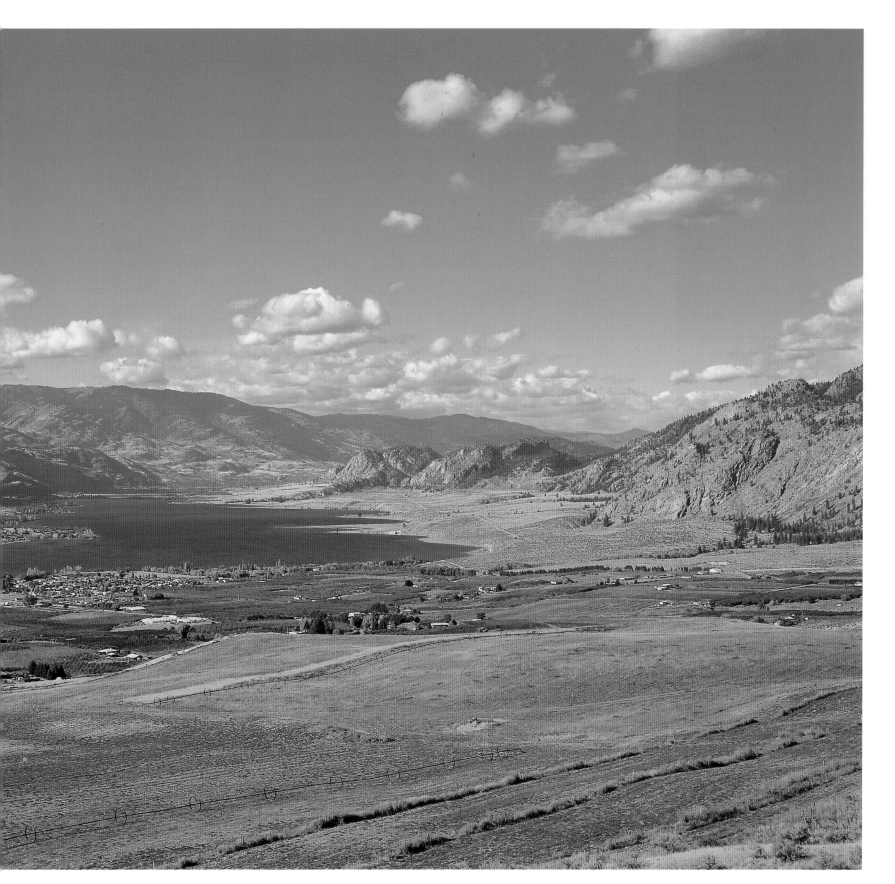

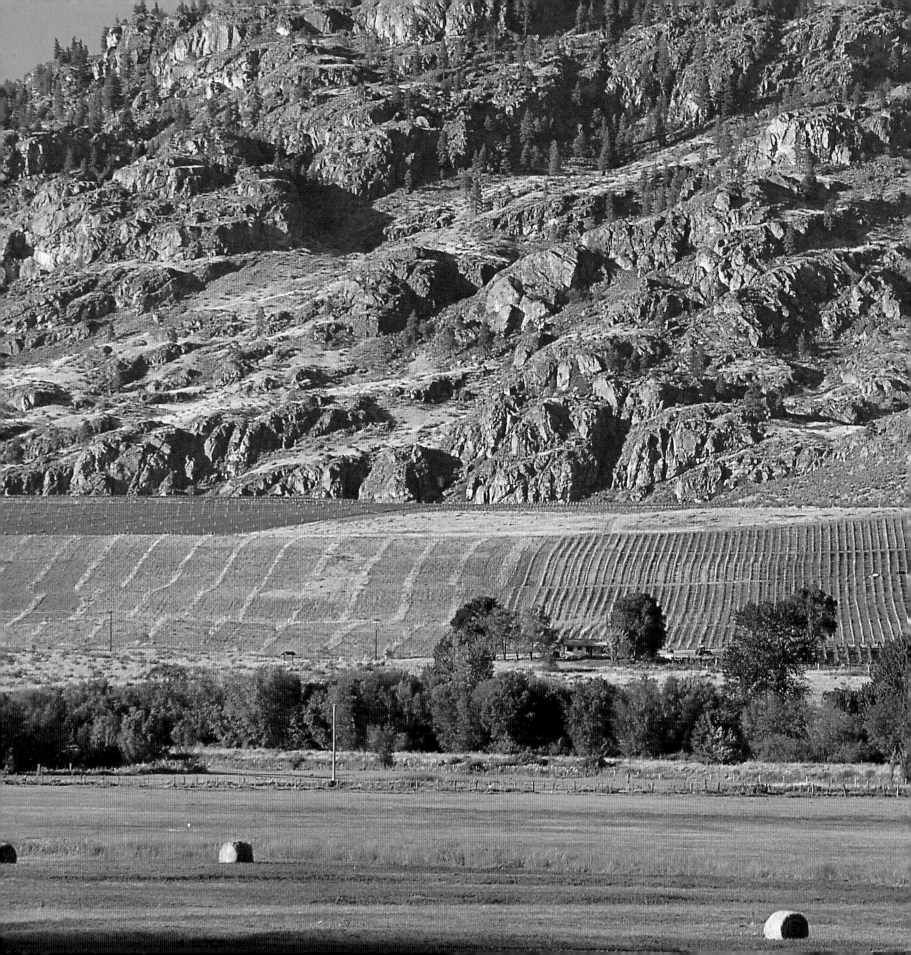

The fame of area produce has led to a unique brand of agritourism. Many farms, orchards, fruit-processing plants, and wineries offer tours. These are becoming steadily more popular as the Okanagan continues to grow.

Photo Credits

Darwin Wiggett/First Light 6–7, 70–71, 89

Hugo Redivo 8, 16–17, 34, 35, 42, 80, 82–83

Ron Watts/First Light 1, 3, 9, 30–31, 32–33, 39, 43, 60, 72, 86–87, 90, 94–95

David Nunuk/First Light 10–11, 19

Alan Sirulnikoff/First Light 12, 78, 81, 84–85

Michael Burch 13, 25, 27, 36–37, 40, 50, 51, 52–53, 56–57

Trevor Bonderud/First Light 14–15, 18, 22, 24

Ken Straiton/First Light 20–21, 49, 55, 61, 62, 63, 68, 74–75, 76

C. Conger/First Light 23

Steve Short/First Light 26, 79, 91

Natalie Chapman 28–29, 38, 45, 66, 73, 77

Michael Keller/First Light 41

Big White Ski Resort 44

David Prichard/First Light 48

Richard Hartmier/First Light 46–47, 58–59, 64–65, 92–93

Chris Harris/First Light 54

Joanne M. Mogridge 67

Murphy Shewchuk 69

Robert Lankinen/First Light 88